Books are to be returned on or before
the last date below.

KT-239-091

LIBREX-

GREEN DESIGN

Mark Batty Publisher

Green Design
Edited by Buzz Poole

Design and Production: Christopher D Salyers
Photography: John Putnam (pp 17, 19, 26, 30, 31, 33-34, 40-55, 82-89, 92-93, 104-105, 108-109, 117, 121, 122-123, 125, 138-141, 149, 153, 154)

The publisher wishes to thank in particular: Lindsay Kurz, Coley Malloy, Kimberly Sandberg, Graham Hill, Simona Jansons, Nicole Recchia and all the artists and designers progressively influencing green design.

This book is typeset in ITC Avant Garde Gothic and ITC Franklin Gothic

Library of Congress Control Number:
2006923832

Printed and bound in China through Asia Pacific Offset.

10 9 8 7 6 5 4 3 2 1 First Edition

This edition © 2006

Mark Batty Publisher
202 West 40th Street, 5th Floor
New York, New York 10018-1504

www.markbattypublisher.com

ISBN: 0-9762245-8-5

TABLE OF CONTEN

TS

INTRODUCTION

CAN DESIGNERS SAVE THE WORLD? by Jenn Shreve

To hear environmentalists tell it, contained in nearly every consumer product being produced today—from plasma screen TVs, DVD players and iPods, to the cheap pair of flip-flops and paperback book you bought for your last vacation—is a pint-sized ecological disaster that, when combined with all the other pint-sized ecological disasters, adds up to ecological apocalypse.

They have a point. Before hitting retailers' shelves, the PVC in those flip-flops may have already given a factory worker testicular cancer. Toxic inks from the paperback have polluted the air inside and around the printing press, meanwhile the forest is short yet a few more trees. That sleek plasma screen may be smaller than your old clunky cathode-ray tube, thus requiring fewer materials to produce, but it's sucking up way more electricity every time you turn it on.

Thanks to built-in obsolescence, your DVD player and iPod are likely to stop functioning altogether in just a couple years. And then what?

Well, if you're a truly remarkable citizen, you might do some research and wind up driving your snazzy hybrid twenty miles to the nearest recycling center, where you'll be asked to pay for the comfort of knowing your discards will be given new life or, at least, responsibly disposed of. Alas, when it comes to things like flip-flops, there are no obvious recycling options, and with electronics, you may simply not have the time, cash or access to a recycling facility to make the responsible choice a feasible one—which is why, in spite of many good intentions, most erstwhile products wind up as landfill. In the case of electronics, their batteries, copper, lead, mercury, halogenated flame-retardants and water-wasting circuitry will continue to poison the planet long after you've shuffled off your mortal coil.

Of course, very few shoppers think about asthma or birth defects while eyeballing the latest digital cameras, laptops and other goodies. For all but a few eco-savvy consumers, price, functionality, convenience and aesthetics are going to be the deciding factors, often in that order. When it comes time to get rid of something, most consumers prefer to think of their discards as garbage rather than, say, nutrients in a larger technological and biological life-cycle. After all, the garbage can is right there; whereas to find out whether the manufacturer has a product take-back program requires work and possibly cash. Unfortunately none of this is likely to change any time soon.

What can change are the products themselves—how they are made, what they are made of and what happens to them once their immediate usefulness has expired. The people best able to make these types of changes are not consumers but designers.

Historically we are at a point where environmental intervention begins at a product's conception. As Dani Tsuda, a senior consultant with the global environmental consulting firm WSP Group, explains: "In the 1970s, with Earth Day as the kick-off point, we were taking care of issues you could see and taste—air and water pollution, hazardous waste and toxic substances, the Love Canal tragedy—with 'end-of-the-pipe' types of pollution abatement. In the '80s, we moved into a period of waste minimization and pollution prevention. So environmental efforts shifted into production and manufacturing, reducing pollution, and the minimization of wastes. In the '90s, especially in Europe, environmentalists and policymakers began looking at phasing out the use of problematic hazardous substances found in the design of products—in the product's manufacturing processes and at the product's end-of-life, what happens to the substances when the product is no longer of any use."

In the new millennium, the emphasis on designing products that are sustainable, described in a 1987 United Nations report as meeting "the needs of the present without compromising the ability of future generations to meet their own needs," has continued to be defined and refined. This latest approach has necessarily involved a whole new stratum of people and skill sets—engineering, product development, management and especially design—in an area once restricted to a few marginalized environmental specialists.

Of course, wanting sustainable design and actually doing it are two very different things. As Sophia Wang, a consultant with the same firm as Tsuda, points out, "A designer coming out of school—even a very good designer and very aware of environmental issues—is still faced with basic design challenges of cost, short schedules and client demands. Being able to weigh all of these options into their designs as well as incorporate environmental issues can be a huge challenge, particularly for young designers straight from school."

To assist designers and their employers in designing products that are eco-friendly from the get-go requires standards, metrics and other tools, like the Environmental Protection Agency's successful Energy Star program, which rewards products and buildings that meet its specific energy-efficiency standards, or EPEAT (Electronic Product Environmental Assessment Tool) a similar independent program for computers, laptops and monitors. Among the most complete and well-respected of these is the Cradle to Cradle Certification Program by the environmental design consulting firm MBDC.

Cradle to Cradle (C2C) is revolutionary in that it challenges the notions of "waste" and a product's "end of life." Instead, it posits that so-called waste is actually food, nutrients that feed other biological or technical life cycles. And rather than ending, C2C suggests that a product can be designed to have one useful life after another. James Ewell, a senior project manager at MBDC, summarizes it as such: "We design products so that people are using the safest materials possible when making them, but also designing them so that when the product is through its first iteration of utility, it can be deconstructed and the materials reused."

The underlying belief is that if products were designed to be made from benign substances, using processes that cause little harm and built so that they're easily recycled (called "Design for Disassembly"), then we could rely less on consumers to put the earth's long-term health before their own whimsical desires. Businesses wouldn't need to grudgingly follow flimsy regulations anymore because design would make compliance natural and cost-effective. The long wait for government-funded recycling programs and tax breaks for acquiescent corporations to finally make an earth-saving difference would be over. This vision is at once pessimistic and naive, but wouldn't it be great if it really started happening on a large scale?

Maybe it will, but for now it's an approach taken on by just a few socially conscious companies. For the rest of the world, what motivates change tends to be punitive legislation. Happily, the European Union has just approved two major new directives which are forcing companies around the world to reexamine how their products are made. The Restriction of Hazardous Substances in Electrical and Electronic Equipment (ROHS) forbids the use of six hazardous chemicals in products sold in Europe starting in July 2006. The Waste Electrical and Electronic Equipment (WEEE) directive has made manufacturers, sellers and distributors of such products financially responsible for their collection, treatment, recovery and disposal since August 2005. For sustainable design advocates, it's a positive start.

"We don't believe that regulations are the most effective approach to better design, but these European directives have forced the electronics industry to focus on important issues related to the design, manufacture, recovery and

reuse of their products. Sometimes it takes such regulations to make industry reexamine their assumptions and to do novel things in the design process," says Ewell.

Alas, compliance with even very good regulations doesn't equal sustainability. Designers and engineers within corporations that aren't already committed to environmentally sound policies still find themselves challenged by a number of obstacles—from crunched timelines to limited budgets to simply garnering support from the departments who hold the strings. "You have to be a good designer first, then influence decisions based on what you know about the environment," says Wang. Even with the best intentions, designers need the proper education, which is another hurdle since academic institutions have been slow implementing comprehensive sustainable design curriculums.

But one of the biggest environmental challenges of today stems from the globalization of the supply chain. It's difficult to say with certainty anymore where any multi-component product, like a cell phone or a digital camera, has been made, because more likely each part was made in a different place. "If you rely on a relatively small, specialized part vendor that produces a part that goes into your product, you need to understand how that part was built, what chemicals were used, what are the manufacturing processes. And not necessarily just environmental issues, but social issues may be integrated as well: Are you using child labor, do you have worker protection safety programs, or are you using appropriate worker safety equipment like gloves or respirators?" says Tsuda.

Plugging these hazardous leaks throughout an entire supply chain can be hugely difficult, especially when you're talking about products with hundreds or thousands of individual parts, but there's a nice upside. Once producers change their lines to accommodate one eco-friendly customer, they probably won't keep switching back and forth, meaning that companies which aren't as concerned about environmental safety will still wind up with more eco-friendly components in their products.

In spite of these ongoing struggles, real change is afoot. Thanks to the lingering effects of past environmental design movements—from Frank Lloyd Wright and the Arts and Crafts movement to the Whole Earth Catalog, recycling and beyond—a large body of consumers are demanding eco-friendly products. These consumers, defined as LOHAS (Lifestyles of Health and Sustainability), represent by some estimates 30% of U.S. consumers, a $226.8 billion market. While businesses can ignore a few do-gooder designers within their ranks, they can't ignore consumer demand on this scale. Combine that with government regulations and fear of lawsuits and now you're fluent in the language of international business: money.

Most earth-friendly design is still a boutique kind of thing: expensive, fabulously designed, but beyond the aesthetics and price-range of the average K-mart shopper. (One thing that sets LOHAS shoppers apart is their ability to spend up to 20 percent more for eco-safe products.) Recalling one eco design competition entry, Wang describes a computer keyboard where the housing was made of a compressed carrot mixture. "The idea was that instead of using plastics, you could use this and throw it in the compost. That's great, but will someone

realistically buy it? If they did, what would they do with the keyboard that came with their computer?" she says.

Of course, for every rabbit-friendly keyboard there are mainstream examples of great sustainable design from places as obvious as Herman Miller to more surprisingly the industrial carpet makers Shaw Industries. Herman Miller, which came about as close as one can get to a blockbuster in the office chair business with its Aeron, has come up with a significantly less-expensive, but no-less comfy or attractive Mirra chair, designed for disassembly, made from recyclable materials and almost fully recyclable itself. Shaw, an industry leader, has made its carpets fully recyclable and replaced the harmful PVC backing it had been using.

That's not to say that designers who make super froufy hemp-based lampshades and biodegradable lawn chairs are barking up the wrong tree. Their work serves as proof of concept, examples that can be modified for reproduction on a mass-consumer scale. Wang says, "Ultimately, the best environmentally designed products are going to be sold at Wal-Mart because Wal-Mart says it's a good price point and a good product and people are going to buy it. Behind it it's going to be manufactured in socially responsible ways, not going to have hazardous materials; it's going to have rechargeable batteries—but that's not necessarily going to be the first reason people are going to buy it."

GREEN TOYS & GAMES

LEGOs: The Key to Immortality?
by Dominic Muren

Chances are the idea of toy design resonates happily in your head. Do idyllic thoughts of happy children and fun-filled toy factories dissipate with the knowledge that the toy industry is among the most unsustainable in the world? The constant flux of what toys are "fashionable," coupled with a reliance on cheap materials and unsustainable manufacturing practices have made toys into a monster of social, environmental and educational poverty. But, as in any good children's story, there are a few heroes fighting bravely against the odds to make toys safe, wholesome and most importantly, fun.

Before the 1960s, toys were literally a cottage industry, with craftsmen making dolls and tin soldiers in back rooms. By the end of the Second World War, there were hundreds of specialty toymakers in the United States and Europe, along with toy companies like Hasbro (Mr. Potato Head), Parker Brothers (Monopoly, Sorry, Clue), Milton Bradley (Life, Scrabble, Yahtzee) and Mattel (Barbie). The toys were produced out of materials like cardboard, wood and metal. In the 1960s, the rise of toy invention companies like Marvin Glass & Associates and Eddy Goldfarb changed the face of the industry forever. The development of low-cost toys produced using injection molding meant that toys were cheaper to buy and parents could afford more of them. This called for toy developers to come up with a greater variety of options to fill demand and eventually led to the current toy trends where most products stay on the market for only a year or two. This, in turn, led to a drive for even lower costs, forcing manufacturing overseas where low-quality working conditions exist.

All of this adds up to an industry in trouble when it comes to sustainability. For cost reasons, virtually every toy sold today is made from plastic. None of the plastic is from biological sources (like corn starch polymers), or from reclaimed old toys (except for the occasional factory re-grind of rejected parts). Relentless advertising forces new toys into homes every year and forces millions of pounds of old toys out, a fact apparent in overflowing thrift store toy sections and mountainous landfills. On top of that, toy manufacturing virtually demands the cheap labor of East Asia, and the huge amounts of shipping energy that go with it. All in all, it's quite a pickle the industry has worked itself into; no single part can easily be given up without undermining the low cost that consumers expect.

In order to rise above this, companies have had to find ways to work within the existing system to create change. The most shining example of this world-saving spirit is embodied in red plastic bricks. From its modest beginnings in 1932 through its adoption of mass production, The LEGO Company has maintained a commitment to its founder's motto: *Det Bedste er ikke for godt* or roughly, "Only the best is good enough."

The LEGO Company began as a Danish carpentry shop making wooden toys in addition to everyday items like ironing boards and step ladders. In 1947, five years after a fire destroyed the original factory and a new one was built, The LEGO Company became the first Danish company to purchase an injection molding machine for making toys. After 10 years of perfecting the design, manufacture and identity in the Danish market (Automatic Binding Bricks became LEGO® bricks—the word "LEGO" coming from the two Danish words *leg*

and *godt* for "play well"), the LEGO system of play, comprised of 28 construction sets and 8 vehicles, was exported for the first time in 1955. Introduced to the U.S. in 1958, the familiar brick design with pegs on top, tubes on the bottom and the colorful instructions for assembly have remained fundamentally unchanged.

During 1959 and 1960, two events crucially defined the future path of The LEGO Company: The Futura division was founded, charged with dreaming up new sets using existing bricks, and another fire destroyed the company's entire stock of wooden toys, which convinced them to finally abandon wood in favor of plastic. Over the next 40 years, the company grew. Four new factories employed nearly 10,000 people worldwide and numerous new designs were made public, like the popular Pirates line, the DUPLO® line for youngsters, the mechanical TECHNIC line and the iconic minifigures, or plastic LEGO characters.

For all the changes, The LEGO Company has maintained a number of qualities that make it environmentally and socially sustainable, in addition to being one of the most successful toy companies in history. The first, and possibly most important, is private ownership. The entire LEGO Company is privately held by members of the family of Ole Kirk Christiansen, the original founder. As the size and reach of any company grows, especially when that company is involved with children, the appeal of legal sanctuary through incorporation as protection from lawsuits grows stronger and stronger. By avoiding corporate protection, the Christiansen family also retains financial and moral control of the business. When issues like plastic toxicity, waste disposal and product safety come up,

they are handled in-line with the company motto. This has helped in many of the other areas that add to their sustainable appeal, particularly in manufacturing quality and production location.

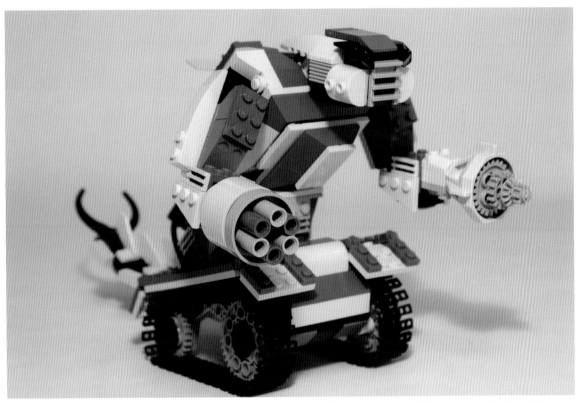

A robotic design using pieces from multiple sets. Design, assembly and photo by John Putnam.

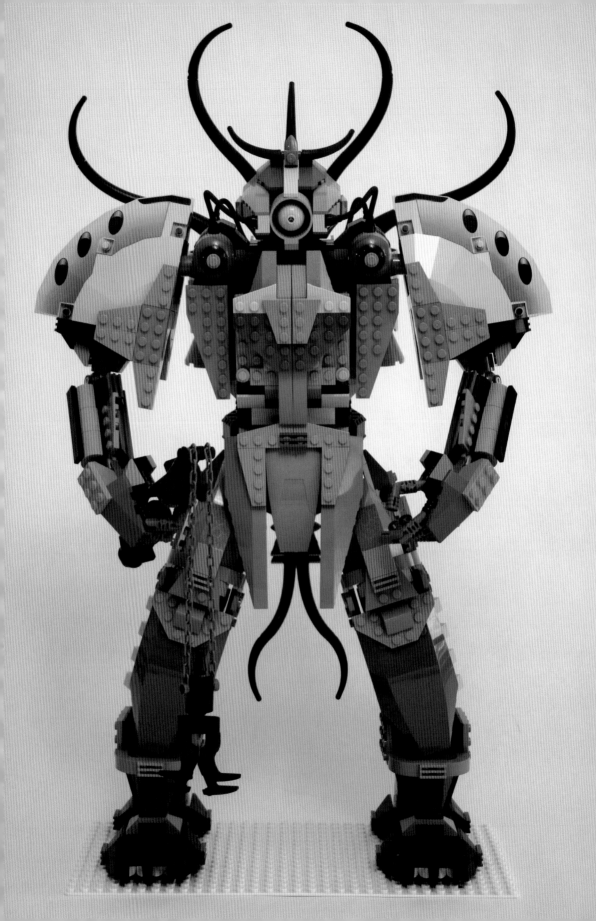

Crucial to The LEGO Company's sustainability is the high manufacturing quality. LEGO bricks are made to one of the most exacting tolerances in toys—just eight ten-thousandths of an inch, or about one 10th the thickness of a human hair. They are made from ABS, a high performance plastic resin used in everything from car parts to building materials. Before those bricks leave the factories, they must pass a battery of size, strength, flammability, toxicity, colorfastness and "gripping strength" tests. The LEGO Company's most valuable secret is

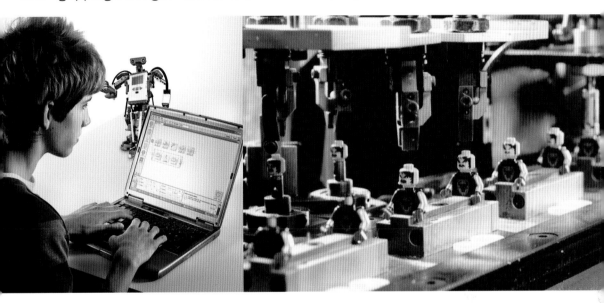

its carefully guarded method for producing these high grade, high tolerance pieces at an affordable price. High quality means long life, and in a business where few products are reclaimed or recycled—ever consider putting an old toy in the recycle bin?—the next best thing is to allow parents to pass toys on to their children, or sell them to their neighbors. Even after years of use, LEGO elements hold, look and play like the new ones straight out of the box.

Opposite Page:
A robotic design using pieces from multiple sets.
Design, assembly and photo by John Putnam.

However, high quality production doesn't mean anything if there are poor working conditions in the factory, or if a huge energy load is needed to ship the finished product to its destination. Ever since its first adoption of injection molding technology in 1947, The LEGO Company has continued pushing the technological edge, to the point where production operations are largely automated and computerized. First, this eliminates the need for low-wage foreign workers, allowing LEGO to pay its workers a living wage. Second, The LEGO Company can place production near the market, rather than near the labor. Proximity to market allows for much lower energy use to get the product on the shelves and lower carbon emissions than if it had been shipped from Asia. Other toy companies, like Hasbro Games, have adopted this model with some success. Hasbro makes its board games for the North American market —Monopoly, Risk, Candyland and Sorry among them—at its original factory in East Longmeadow, Massachusetts, not far from The LEGO Company's North American distribution node.

Releasing such a long-lived product into a market with such a short attention span as toys requires some careful thought. Children grow up quickly and once a kid outgrows a toy it's usually discarded or sold. The LEGO Company avoided this scenario by making a modular, backward compatible system. Every LEGO brick since the first can be used with every other brick, and in dozens of ways within a model. Any 8-year-old will demonstrate this by using roof tile bricks as a nose in a face, or shock absorber TECHNIC pieces as doll legs. In order to further such variations, The LEGO Company has produced full model-style sets, in addition to catalogued parts that may be ordered on an individual, or bulk, basis. LEGO bricks truly become a building system where there is no waste. Every part is compatible with every other part and the applications are ageless.

Most recently, The LEGO Company has taken this adaptability a step further with the LEGO Factory system. By downloading a piece of software, children gain the ability to design virtually with 37 types of LEGO bricks, and either print out instructions to build the model from their own bricks or purchase a custom produced set that will arrive by mail a few days later. The factory website is a virtual warehouse of collaboration where builders from all over the world can exchange designs, interact with other builders' models and download instructions for any model on the site. All this new software keeps thousands of LEGO bricks out of disuse and out of landfills.

None of these innovations qualify in the traditional sense of sustainability—a word that evokes visions of hemp cloth, biopolymers, recycled waste and solar energy. The LEGO Company's work toward making a better company has, whether intentional or not, created a robust system for sustainable manufacture, distribution and use of a great toy. Reducing supply chain energy, increasing social quality of labor and extending product usage life are all factors that make The LEGO Company a great example of potential in a troubled industry. For anyone looking toward the future of sustainability, remember that the obvious solutions—increased recycling, alternative energy—aren't always the only solutions; sometimes the best place to start is with a simple idea like, "Only the best is good enough."

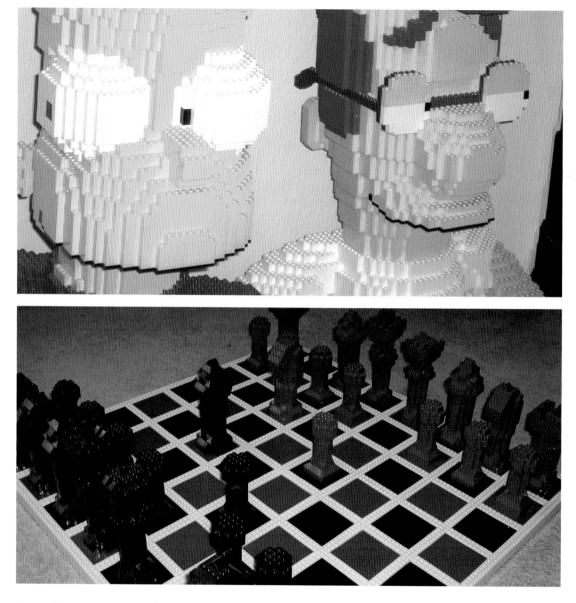

From fine art to pop culture to a functioning grandfather clock, there isn't anything professional LEGO builder Eric Harshbarger hasn't built with LEGOs. Patience may be the key to these objects; they require countless numbers of tiny blocks, but the payoff is amazing.

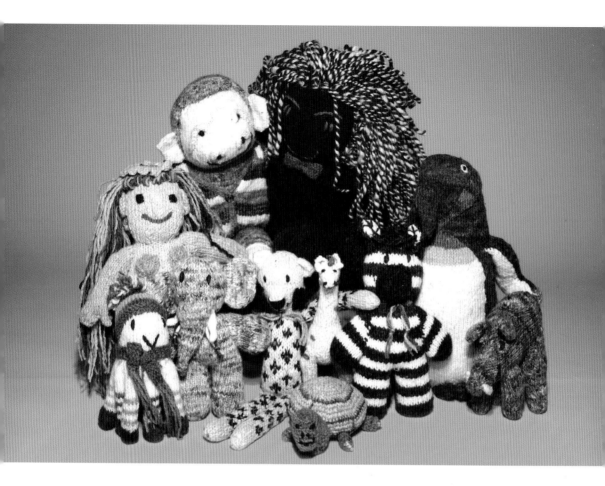

Everything about these critters is joyful, from the smiles stitched across the faces of the stuffed animals, to the stories about the collective of women (and more recently men) who craft the items, to the pride Gloria Delaney, the U.S. representative for the collective, exudes when she tells tales of visiting the artisans or relays a recent update brimming with good news of medical exams, literacy and self-respect. Who wouldn't be proud of an endeavor that benefits all parties involved, from production to customer?

Organized in 2002, the impact that Delaney's help has made on the tranquil farming community of Njoro, where everyday wool is collected from the Kenana Farms and neighboring farms, is astounding. The collective is known as the Kenana Knitters and it was established with the social aim of providing much-needed income to local families in a community where unemployment is rampant and social mores make it difficult for women to find work.

With just a dozen women as members when the project began, the group has ballooned to include over 300 spinners and 200 knitters! More than simply providing jobs that pay fair wages, however, the Kenana Knitters have parlayed their good fortunes so that it betters the community as a whole. AIDS tests and medical exams are now common; 2005 was the first year all the mothers could pay their children's school tuitions in full; the collective's facility has a brand new kitchen that will also double as a station to dry wool during the rainy season; a literacy program has been so successful that reading glasses needed to be ordered for many of the women who apparently had poor vision. For the first time in their lives, these women have bank accounts, the funds from which go to pay living expenses.

More than just material improvements in their lives, however, these women now possess self-assuredness previously unknown to them as a result of the traditionally patriarchal social structure. These women garner an incredible amount of respect from their extended families and the community at large, all because of these cute and cuddly creations.

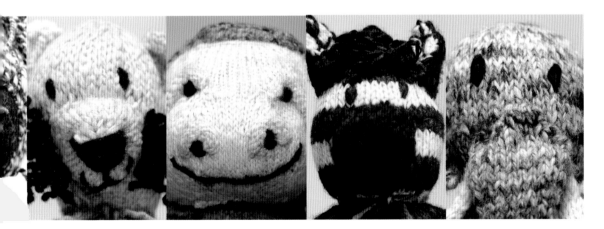

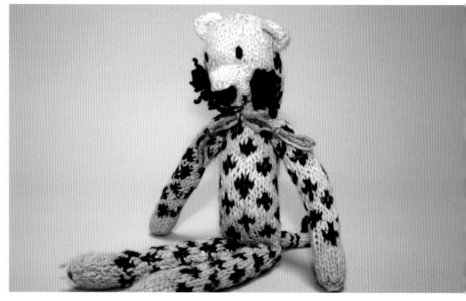

The Cheetah (Artist: Grace Nanyeit)

The Baby Doll (Artist: Anna Simon)

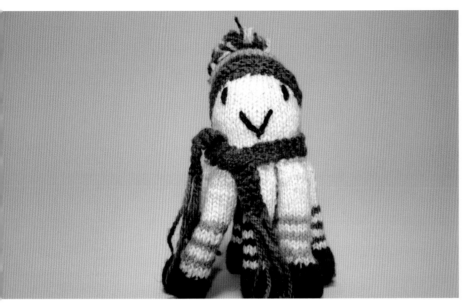

The Octopus (Artist: Maria Epuke)

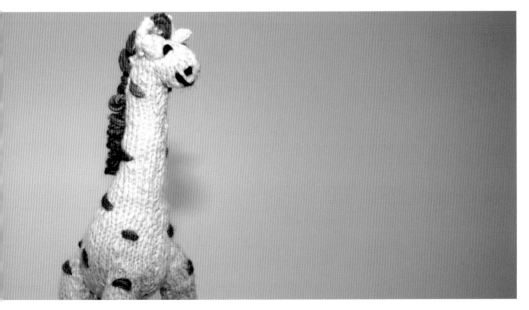

The Giraffe (Artist: Mary Emuria)

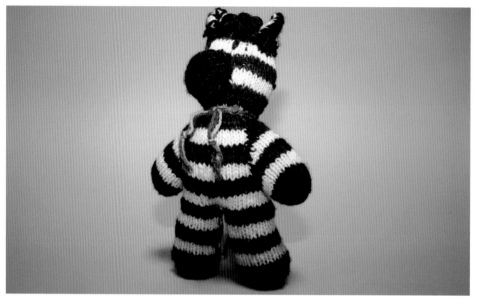

The Zebra (Artist: Janet Apiyo)

The Monkey (Artist: Josephine Nyambura)

The Elephant (Artist: Mitlet Afandi)

The Mermaid (Artist: Florence Chepkemoi)

The Turtle (Artist: Binet Musimbi)

The Penguin (Artist: Freshia Njeri)

The Warthog (Artist: Grace Nanyeit)

The Kenana Knitters use nothing but all-natural, local products for their materials. The wool, grown in the same town where the women work, is washed and colored with all natural plant dyes; the wool is mothproofed with Pyrethrum Flowers (think of a daisy); the women spin the wool on old bicycle wheels; each Critter comes with cards hand-signed by the woman who made the stuffed animal.

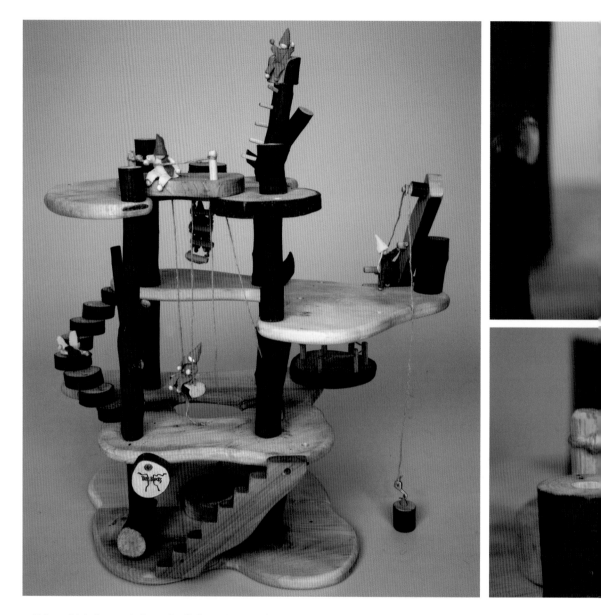

What kid doesn't love building things from scratch, from forts to dollhouses? The people at Tree Blocks figured out a way to merge nature's elegance with human ingenuity, creating building blocks made from wood that otherwise would be wasted. Two methods exist for the acquisition of the wood. The company identifies abandoned or end-of-productive-cycle plots of orchard trees like apple, cherry or hazelnut; they contact the farmers, uproot the old trees and haul them away, leaving the farmer with clean soil and extra money from the sale of the wood that would have otherwise cost the farmer to discard. These types of wood end up as blocks and bridges. From the discards of managed paper forests, Tree

Blocks puts to use Elder wood. In these forests, smaller trees, too small to make into pulp, are regularly cut down in order to make room for the larger trees. These smaller El-der trees would simply be burned, but Tree Blocks uses every part of the unwanted trees to make all the parts of their kits, all of which are finished with flax oil. Because no two trees are identical, the blocks all vary slightly, but are cut to be compatible, so children and adults alike can spend hours fiddling with the pieces to build structures as innovative as the materials they use to build them.

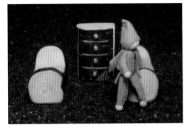

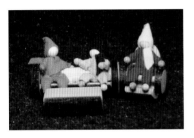
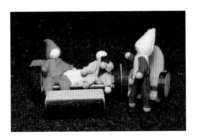

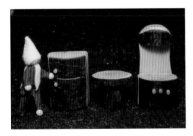

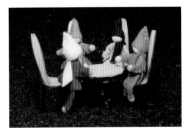

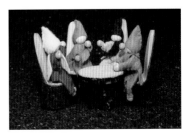

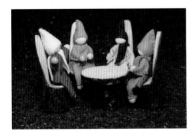

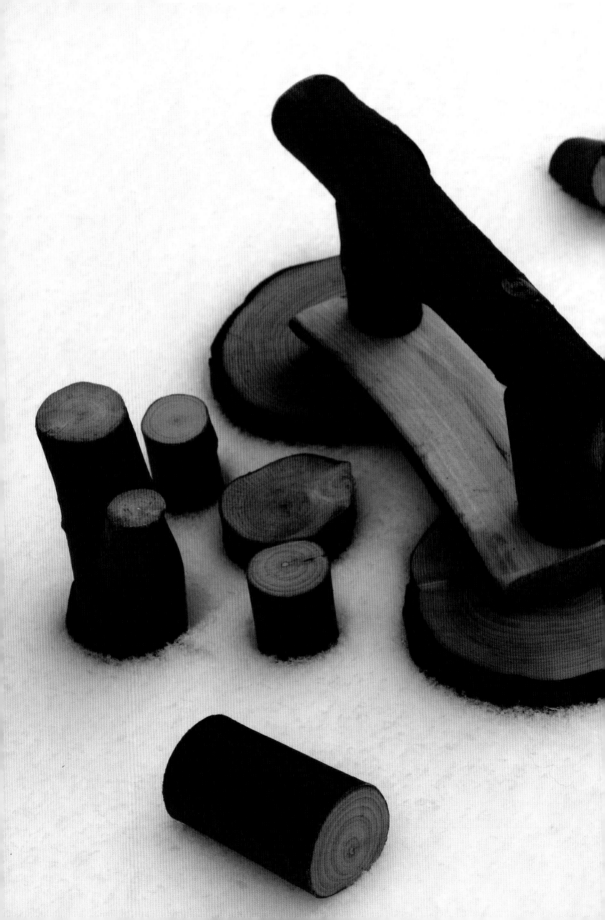

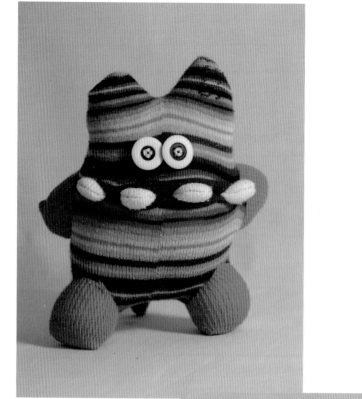

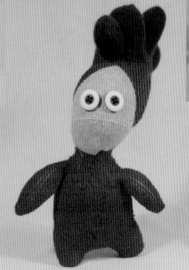

John Murphy's Stupid Creatures consist of wholly recycled materials, with the exception of the thread, from the old socks sent to him from people all over the world, to the buttons scavenged from thrift shops to the recycled polyester fill stuffing reclaimed from old furniture.

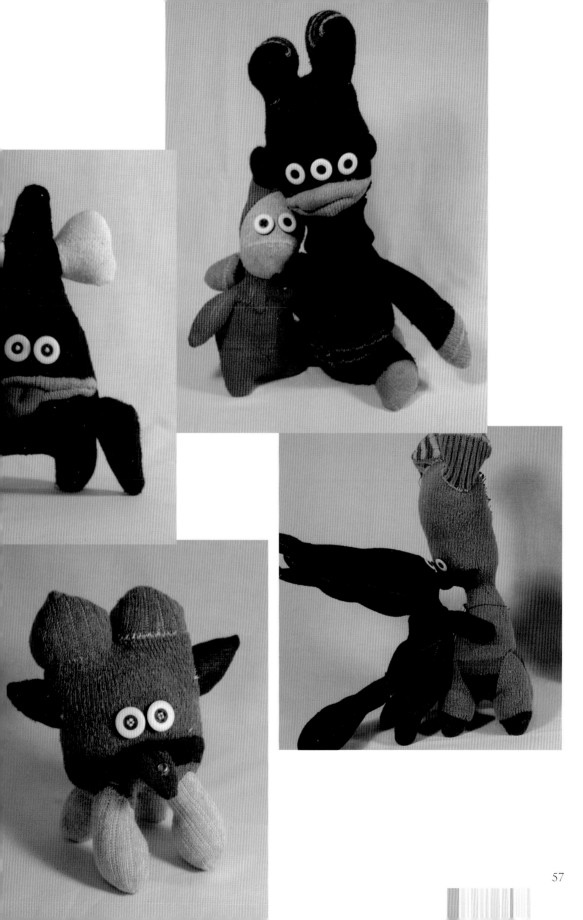

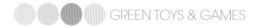

With experiments about series and parallel circuits, Seibun's Solar Wheelie Radical Racer Kit lets kids have fun racing this car around while they also learn about alternative energy.

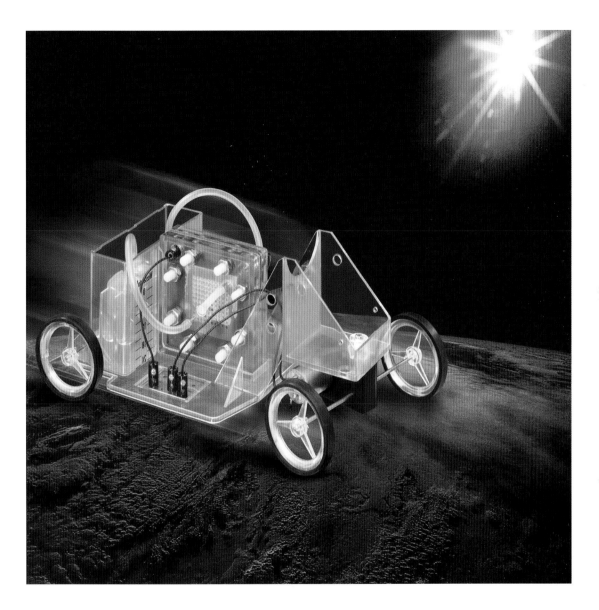

The Fuel Cell Car Kit from Thames & Kosmos exposes users to the 21st century's most significant technology: reversible fuel cells. The kit provides a look at how a car can be powered by water, once the hydrogen is separated from the oxygen. This toy demonstrates how reversible fuel cells will eventually power everything from computers to real cars.

Thames and Kosmos's Power House is the ultimate green learning tool, and toy. Kids and adults embark on adventures in sustainable living when they play with the house, doing everything from harnessing solar and wind power, to generating electrochemical and plant energy. All of the experiments developed by physicist Uwe Wandrey drive home the advantages of sustainable homes, with the hope that the kids exposed to these alternatives will apply the knowledge to their homes when they're adults.

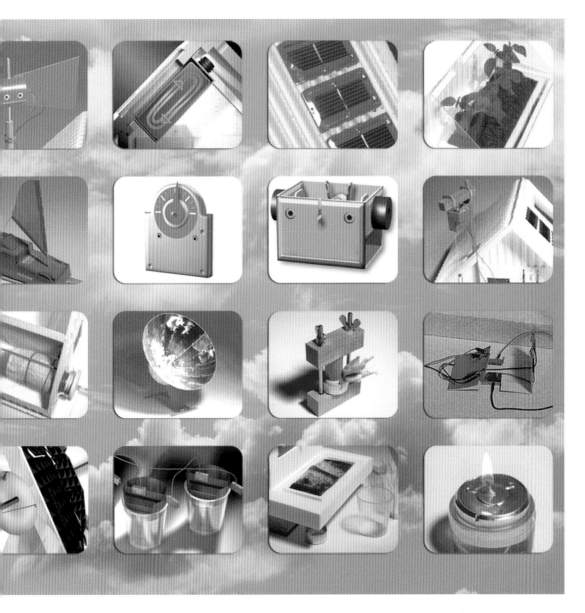

Components of the Power House (from top left corner): electric train, wind-powered generator, solar collector, solar power station, greenhouse, current indicator, sail car, hygrometer, electric motor, electric crane, air conditioner, refrigerator, solar oven, oil press, electric switch, thumbtack scale, light telescope, lemon battery, greenhouse, oil lamp.

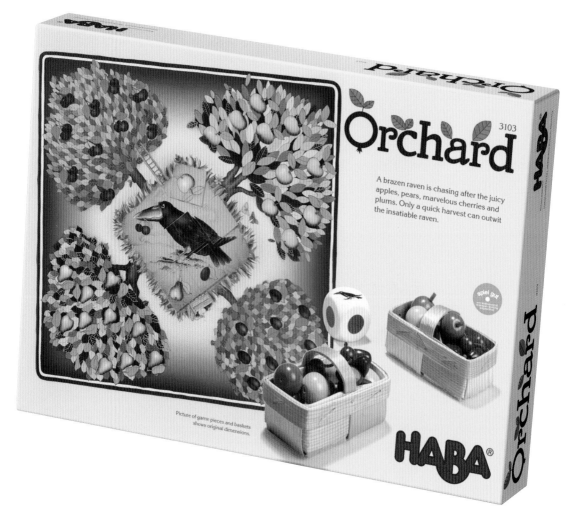

Orchard

3103

A brazen raven is chasing after the juicy apples, pears, marvelous cherries and plums. Only a quick harvest can outwit the insatiable raven.

Picture of game pieces and baskets shows original dimensions.

HABA®

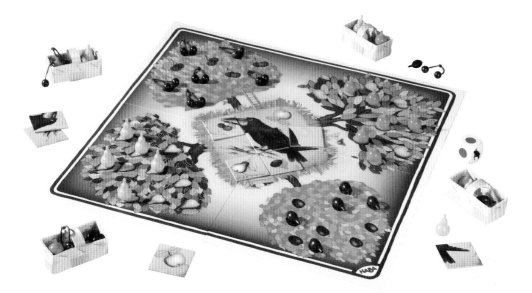

Fun for children as young as three years old, Haba's Orchard board game teaches the collective spirit of harvesting orchards. The purpose of the game is to beat the ravenous raven to the fruit before he eats it all. Not only does this game teach some basic principles of agriculture, it also fits the green category because the board and pieces are non-toxic and made from recycled materials.

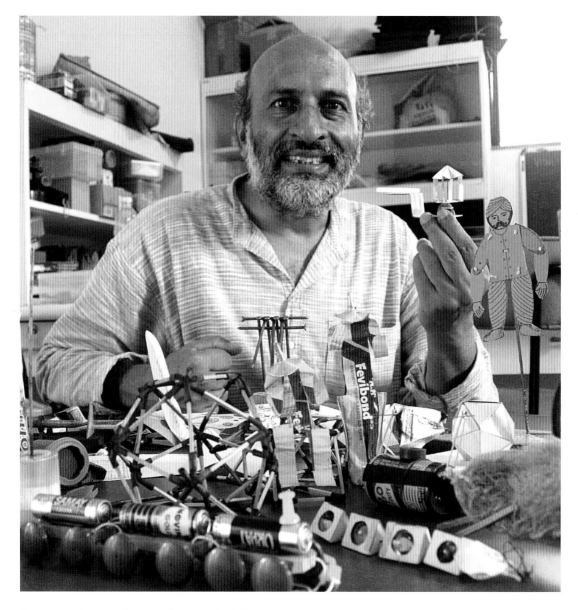

As a teacher and toymaker, Arvind Gupta works with trash scoured from the streets of Pune, India. All of his toys incorporate scientific principles that educate and entertain students, proving that ideas should not be limited by modest resources. Pictured here: rubber cars with button wheels, a soda can airplane and an adhesive tube acrobat.

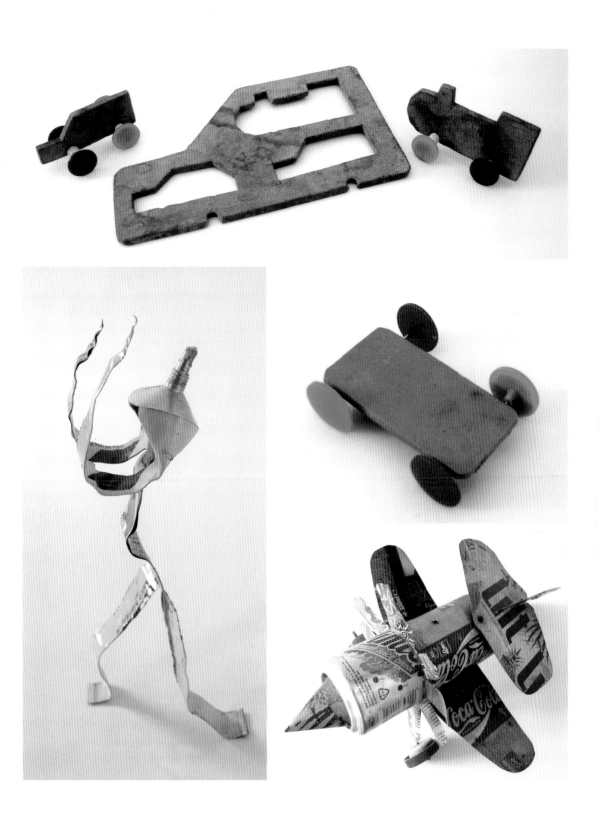

GREEN OBJECTS

Galya Rosenfeld's use of ultrasuede from scraps reclaimed from the upholstery industry blends fashion with arts and crafts. Traditional tools typical for this kind of work, like patterns or thread, are rarely used in the construction of these products. The pillows are filled with natural feathers and down.

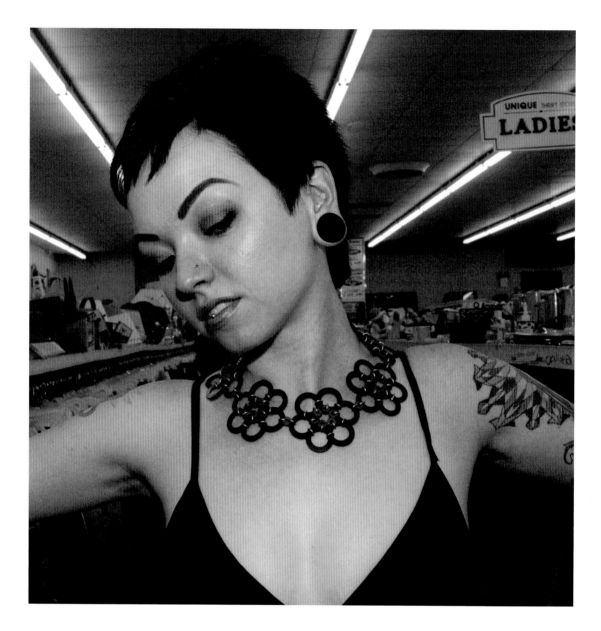

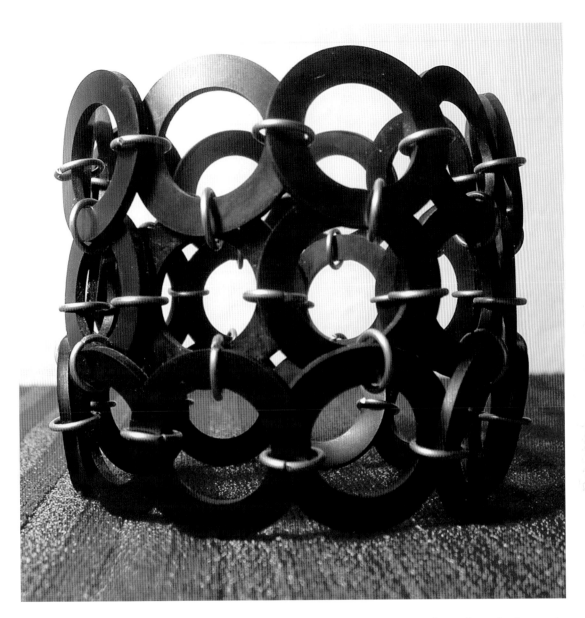

Ten years ago, hemp and hippies dominated the common perception of products made from recycled and alternative materials. Today, nothing is further from the truth. Just look at the ultra-industrial creations from Chicago designer Melissa Kolbusz. Using her hometown as a salvage yard rife with things most people would consider waste, Kolbusz uses recycled and surplus materials like metal and rubber washers and cords, alternator wire and stainless steel springs to create bracelets, necklaces, belly chains and hair accessories. This jewelry appeals to the punk in everyone.

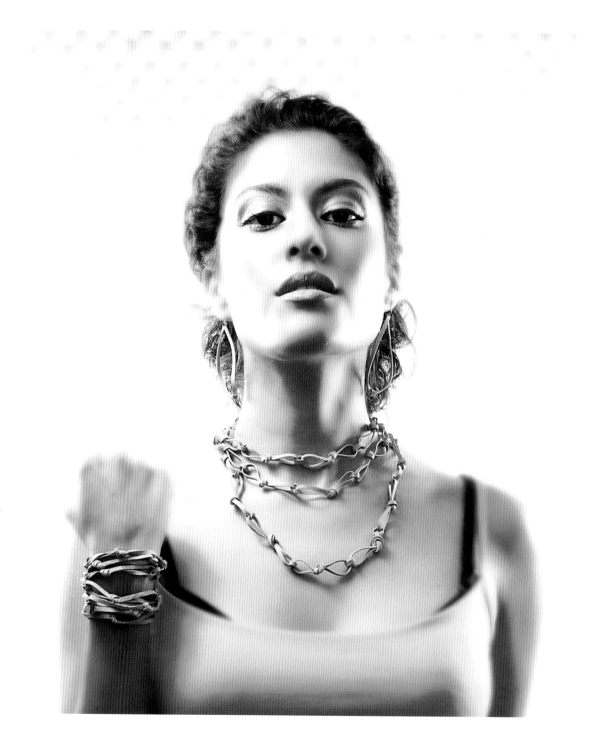

In Spanish, *arre* is the interjection used to spur animals into action. It is also the name of the design workshop in Mexico City founded by Erendira Garnica and Regina Santos-Coy. Their mission, when it comes to design, is making everyday life more significant by converting common objects, many of which would usually just be thrown out, into aesthetic objects. Here, rubber bands, buttons, pins and thread have been turned into jewelry sure to catch people's eyes for its original reuse of materials.

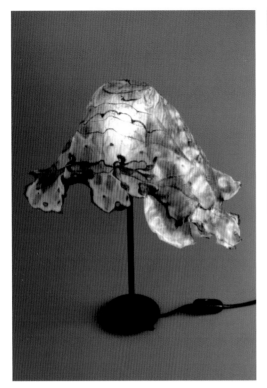

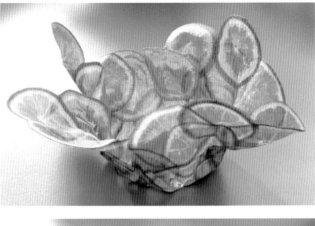

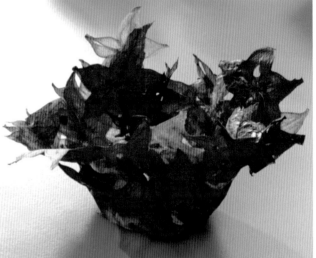

Chosen for texture and translucency, the produce Margaret Dorfman selects for her Vegetable Parchment Bowls and Lamps blur the line between food and art. Called parchment as an homage to the skin parchments of Medieval Europe, these parchments depend on what produce is seasonably available. After being cured, pressed and dried Dorfman shapes the paper-thin slices into bowls and lampshades, every creation wholly unique. Kept dry and out of direct light, the all-natural, chemical-free creations will keep forever. Let the bowls sit as pieces of art or fill them with dried herbs or potpourri. Light, whether from a bulb or a votive candle, shining through these parchments turns commonplace fruits and vegetables like kiwi and purple Savoy cabbage into gem-like materials rich with subtle detail.

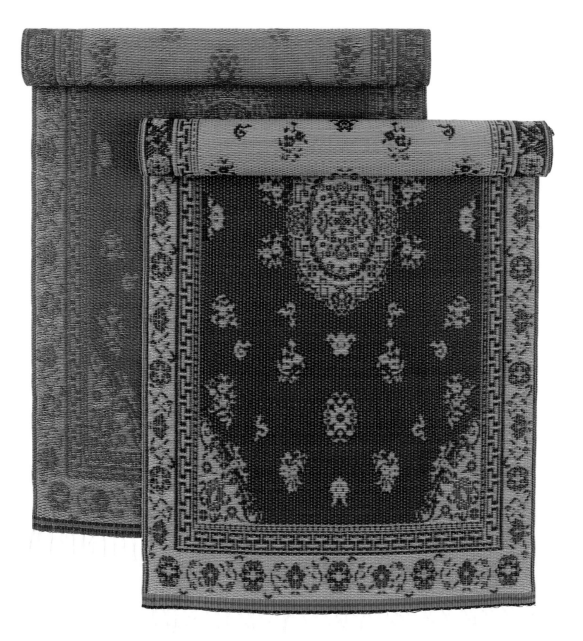

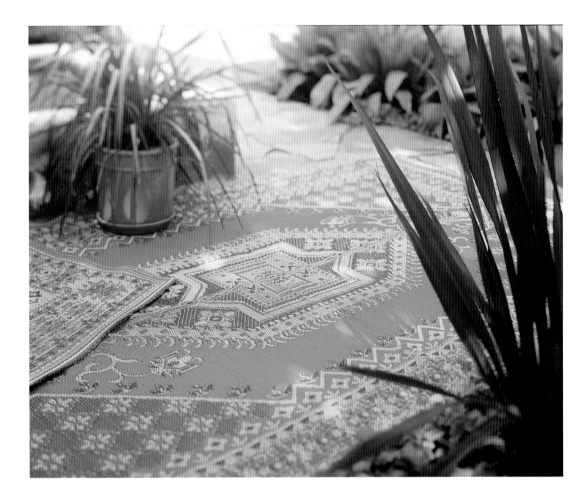

Thai artisans who receive fair-trade wages handcraft these indoor/outdoor rugs made entirely from recycled plastic soda bottles. The colorful strands of polypropylene endure even the most rigorous foot traffic, making these rugs perfect for kitchens, laundry rooms and decks. They're also easy to clean; all you need is a hose.

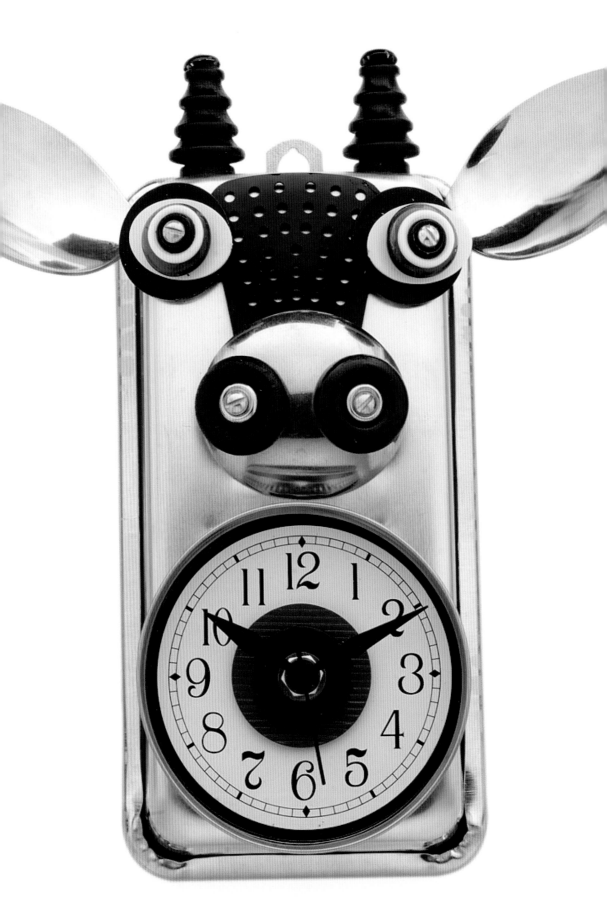

Handmade in Massachusetts by Mark Brown, this cow clock demonstrates how busted kitchenware can be creatively reused. The bread pan face and spoon ears give this cow character. How many other bits of kitchen utensils can you identify?

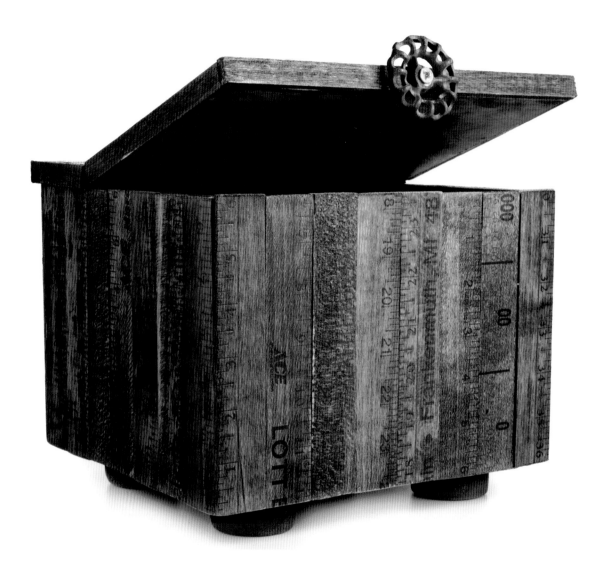

Dorothy Spencer's yardstick boxes evoke days of yore when hardware stores regularly produced rulers as advertisements. Each box is one of a kind, using salvaged rulers, roller skate wheels for feet and water faucet knobs for handles.

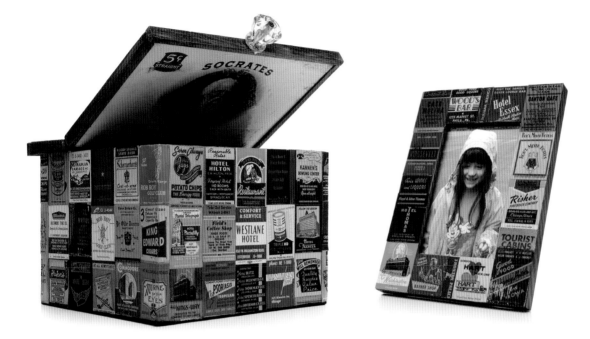

Also made by Dorothy Spencer, the vintage matchbox covers adorning these objects look better as ornamentation that showcases various graphic design approaches from the past than piled into some landfill. The boxes are lined with cigar box interiors and the handles are taken from old cabinets.

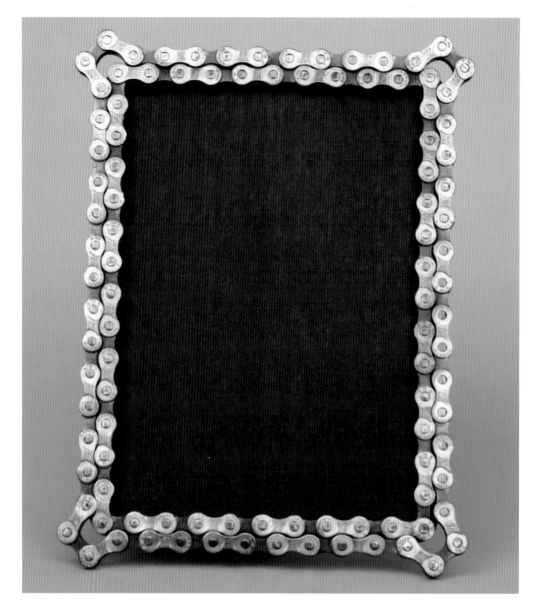

Inspiration can strike when you least expect it. Only after repairing a flat tire on his bike and using the busted inner tube to hang a pair of speakers did Graham Bergh realize the potential of salvaging old bike parts for everything from picture frames to pendulum clocks. Based in Oregon, Bergh now oversees a program that culls 3,000 pounds of used parts per month from 150 shops in 17 states. Parts with a bit of life left in them are donated to workshops that teach bike repair to children; everything else is polished and crafted into these new objects.

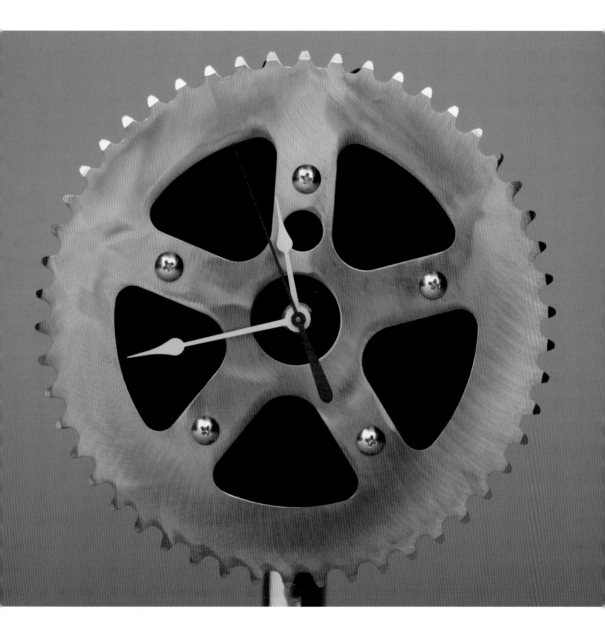

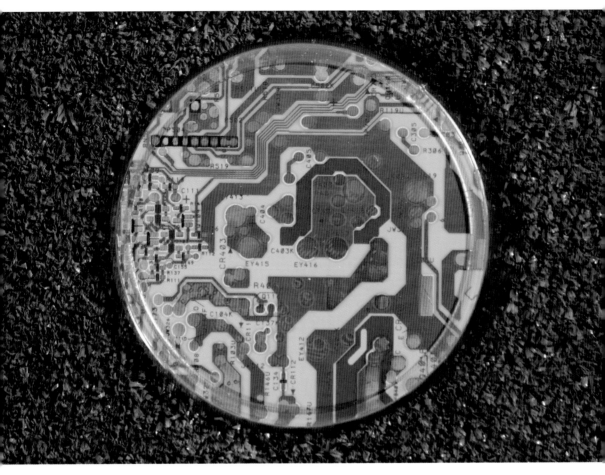

Why have something in a landfill when it could be on your desk? Everyone knows that computer parts are quickly outdated and when that happens there's little else to do with them other than throw them out. Here are a number of attractive and utilitarian ways to better use old circuit boards from defunct computers.

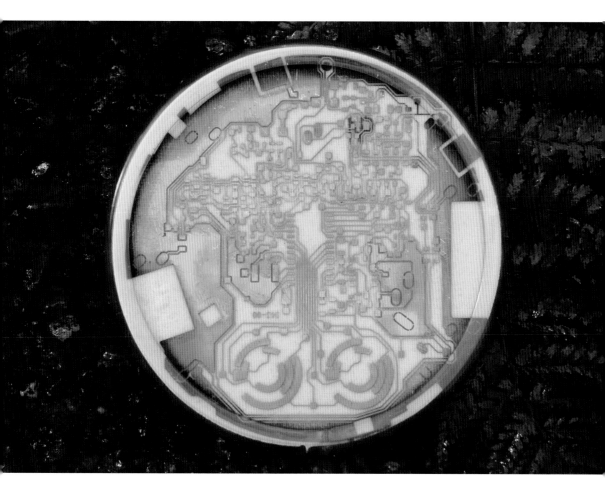

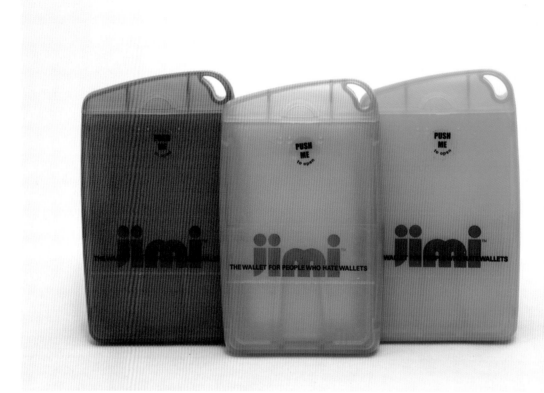

This isn't your dad's wallet, unless your dad's ultra hip. Jimi is the wallet for wallet haters, designed to be thin enough to fit in your front pocket without revealing any unsightly bulges and still provide room enough to fit an ample number of credit cards, ID's and cash. Engineered from 100% recycled and recyclable plastic, Jimi invests 1% of all sales back into the environment.

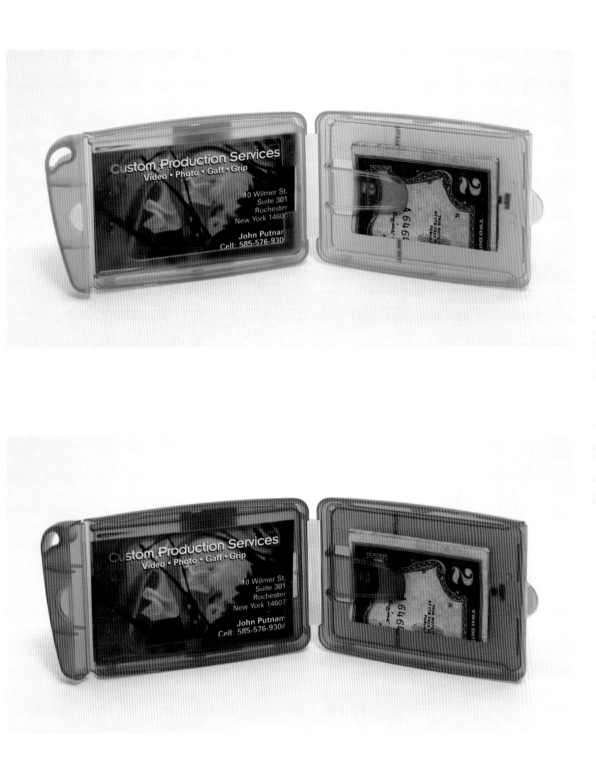

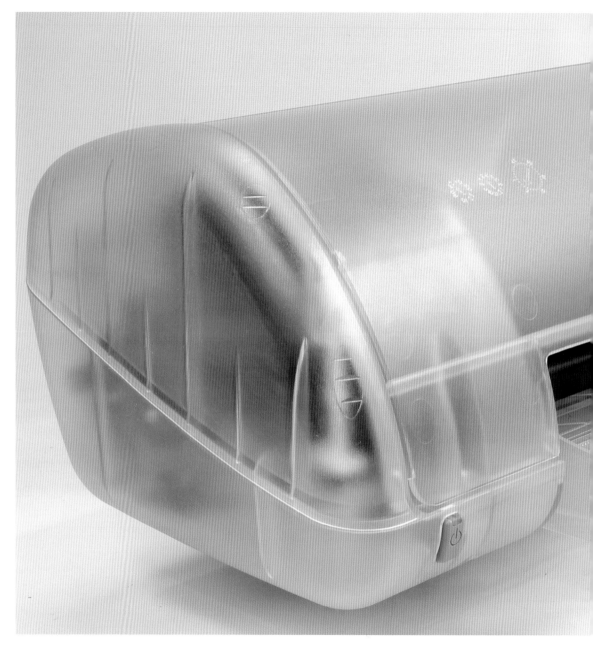

HP runs computer hardware and print cartridge recycling programs in more than 41 countries. In 1997, it was the only major computer manufacturer that operated its own end-to-end recycling facility, of which there is now a second. HP's care for the environment goes beyond recycling; the company also encourages innovative design. This printer's prototype bioplastic case is made from corn. Biopolymers use polymers made from plants, not petroleum, resulting in materials that can easily be broken down when the machine expires.

In a world where compact discs are not too far from being obsolete, vinyl records are considered useless dinosaurs by many people (with the exception of audiophiles who cherish the warmth of sound generated by a spinning record). Jeff Davis has figured out a way to spare landfills of unwanted, scratched records; he makes them into bowls. Mylar protects the labels, making these bowls ideal storage vessels for dry goods.

SD 33-280

BALL
IRON BUTTERFLY

TWO STEREO

ATCO

1. IT MUST BE LOVE
 Doug Ingle
2. HER FAVORITE STYLE
 Doug Ingle
3. FILLED WITH FEAR
 Doug Ingle
4. BELDA-BEAST
 Erik Brann
 (ST-C-68 1498-MG)

MFG. BY ATLANTIC RECORDING CORP., 1841 BROADWAY, NEW YORK, N.Y.

GREEN ENERGY

WHAT A DRAIN!

by Jenn Shreve

How a bad battery can ruin otherwise earth-friendly design.

It's rare for something as small and insignificant as a battery to spark a major, multi-city protest and a documentary short film, but that's exactly what happened in the spring of 2005. The offending power source was the lithium ion which lived in the cramped quarters of Apple's iPod.

The problem? All batteries, even rechargeable ones, eventually die. But as brother-filmmakers Casey and Van Neistat pointed out in their 3-minute flick "iPod's Dirty Secret," iPod batteries typically die in 18 months. And because changing the battery required sending the digital music player back to Apple along with a check for about what it would cost to buy a new one, critics, who

The beauty of this light bulb is that it's solar-powered. Called a Glow Brick, this bulb cased in plastic stores light all day long and at night glows a calming blue. Read by it or use it as a night light, the Glow Brick can work anywhere the sun hits.

also launched protests in California and Texas, rightly pointed to the iPod as a particularly egregious case of poor environmental design and built-in obsolescence. (Apple has since lowered the price of battery replacement.)

To be fair, the very reason the battery wasn't replaceable in the first place—the iPod's compactness—also meant that the iPod required fewer materials to produce and package, typically considered an eco-friendly attribute. To let people crack their iPods open would be to risk messing up the electronics. In other words, you'd wind up with broken iPods either way. The behavioral ramifications of this blockbuster product—people downloading digital files rather than buying wastefully manufactured and transported CD players and packaging—shouldn't be ignored either. This is not to say the iPod is environmentally exemplary, but that compromises were made.

What the iPod controversy does illustrate is the huge challenge that batteries present to environmentally minded designers. An inadequate battery can overshadow a product's more eco-friendly design. Many batteries, such as the lead-acid batteries used in everything from cars to lawn mowers and Nickel-Cadmiums favored in power tools and cordless phones among other things, contain hazardous materials. Others are simply wasteful, like the ubiquitous, cheap Alkaline batteries, which are rapidly depleted by the high-power demands of today's electronics and wind up getting tossed into the trash once they've emitted their last charge. Yet if you're designing anything that requires power, you're going to need batteries, which is why 15 billion batteries are sold around the world per year.

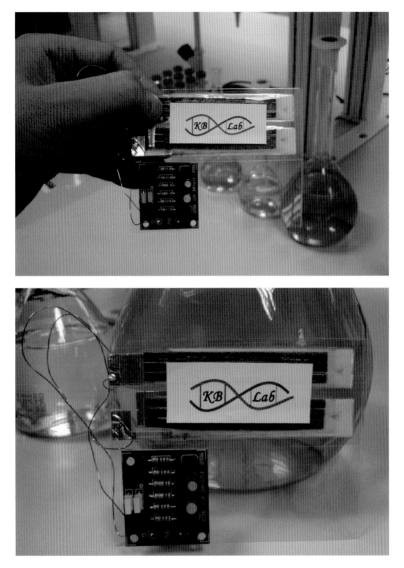

Invented and patented by Dr. Ki Bang Lee, his urine-activated paper battery demonstrates the extent to which scientists and designers strive to lessen our reliance on traditional, environmentally harmful means of generating energy. While still in the early stages of development, Dr. Lee's battery does work. These two images show the battery wired to a circuit.

With the demand for small, portable electronic devices unlikely to wane any time soon, what's needed are better designed batteries. The rechargeable Lithium-Ion and NiMH batteries sold at places like Green Batteries (greenbatteries. com) are less wasteful, better functioning and cheaper in the long run than the lithium or alkaline batteries they replace. But while consumer gadgets have gotten miniaturized and more advanced, the batteries that fuel them have for the most part lagged behind in innovation. And greener batteries have ranged from the expensive and difficult-to-find alternatives to the hand-cranked variety which only appeal to a few diehard, off-the-grid types.

Fortunately, some real breakthroughs are on the horizon. Portable fuel cells, currently being developed by several major electronics companies, don't lose their effectiveness over time like rechargeable batteries do, and they have the added advantage of being environmentally harmless. Though, as a Hitachi prototype of a fuel cell-powered PDA demonstrates, this technology still has a ways to go before it can replace batteries: the PDA was twice as heavy and significantly bulkier than your typical Palm Pilot. Still, industry experts predict we'll be powering up our laptops, cell phones and other portables using fuel cells by the end of the decade.

Other developments, like the credit card-sized, urine-powered battery developed by Dr. Ki Bang Lee in Singapore, may not sound practical at first, but in fact it can power cheap urine-diagnostic devices, which have the social advantage of bringing the capabilities of a medical lab to isolated, rural areas. Meanwhile energy-scavenging batteries, which transform everyday things like the vibrations

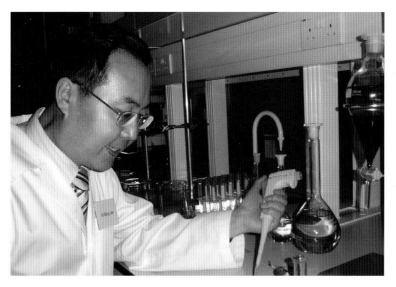

Dr. Lee conducting an experiment with his battery.

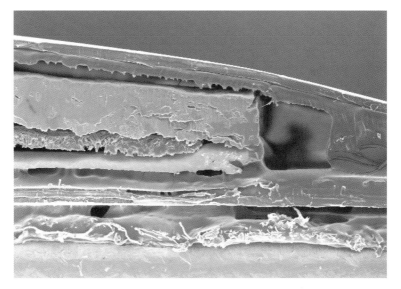

A cross-section of a urine-activated paper batter.

caused by a person walking across the room to ambient heat and light into electrical charges, show a lot of promise to make batteries in small devices more efficient once they move from the research laboratory to the development phase of their existence.

Until these more eco-friendly means of powering our electronic gadgets and gizmos become everyday realities, consumers and designers alike will face the usual trade-off of cost and practicality versus lessened environmental impact. And when all else fails, there's nothing like a little protest to stop a battery from becoming a major drain on the planet.

Opposite:
Modeled after the self-powered radios distributed by the Red Cross to help people stay informed in times of emergency, the American Red Cross FR300 by Etón has been co-branded with the relief agency. The hand-crank generator powers the unit, and charges the built-in rechargeable Ni-MH battery. With this lightweight radio, listen to AM/FM bands, as well as NOAA weather radio; you can also utilize the built-in emergency siren, flashlight and cell phone charger. A portion of all sales is donated to the American Red Cross.

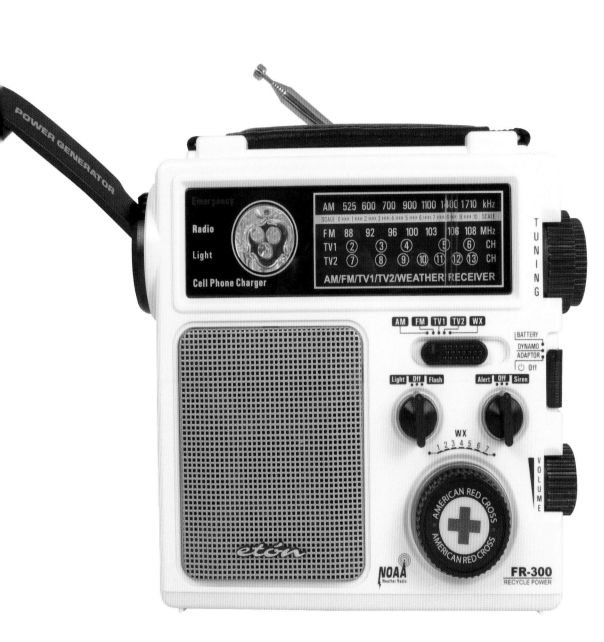

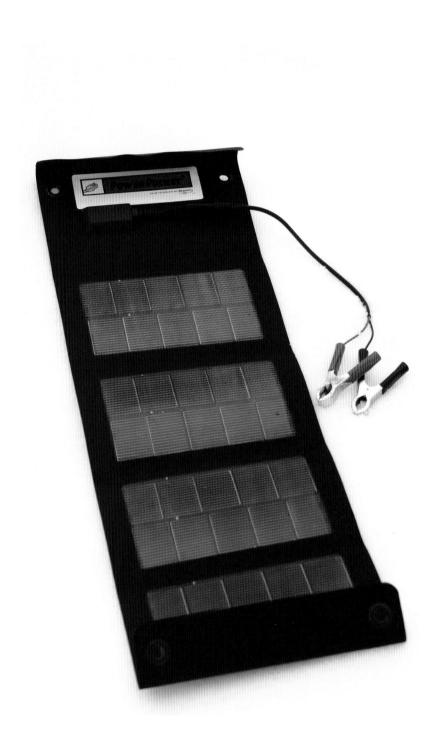

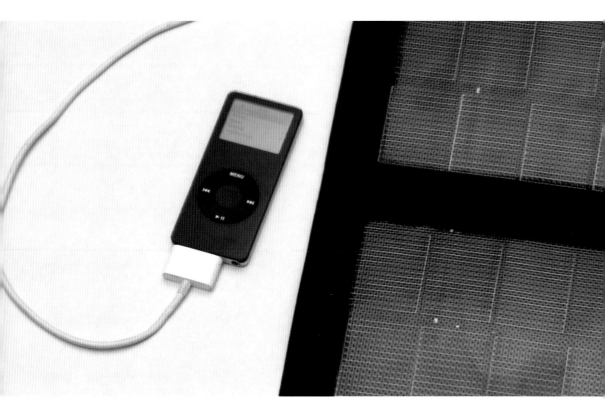

The Power Pocket from Reware holds enough power to charge most micro-devices as fast as they would charge if you plugged them into the wall. Roll it up when not in use; unfurl it when you need it. Hike all morning to the soundtrack of your choice, break for lunch, plug in your music player and in no time at all you'll be back on the trail with the tunes kicking.

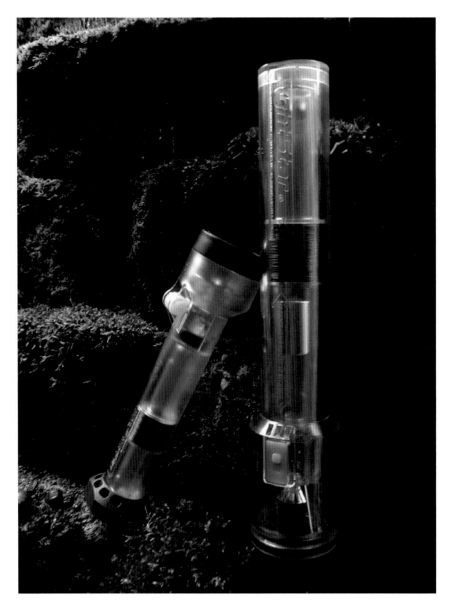

NightStar flashlights are the original, kinetic, magnetic flashlights. No bulbs, no batteries; the light shines for 20 minutes with nothing more than a quick shake. A magnet slides through a wire coil, which produces electricity; a capacitor stores the electricity that powers the LED bulb. Waterproof, durable, practical and ecologically responsible, these flashlights are perfect for emergency kits or a science lesson.

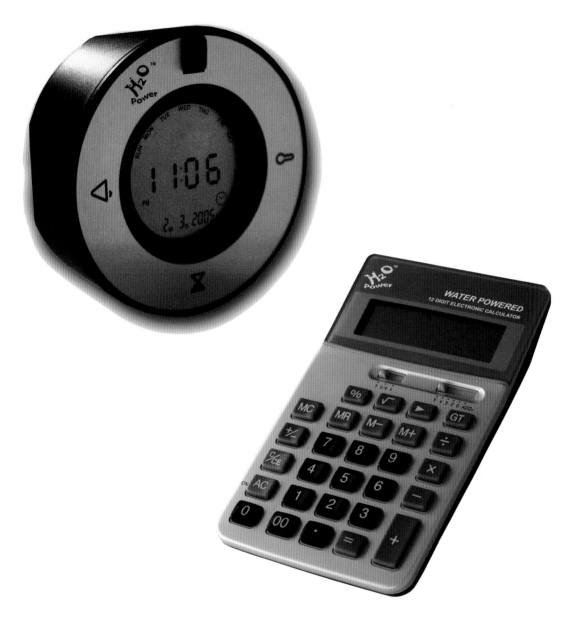

Water, or any other electrolytic fluid of your choice, powers both the calculator and clock. The designers at Group Mango built both items around a converter that extracts electrons from the liquid molecules and provides a steady stream of electrical current acting as a fuel cell to generate power.

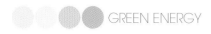

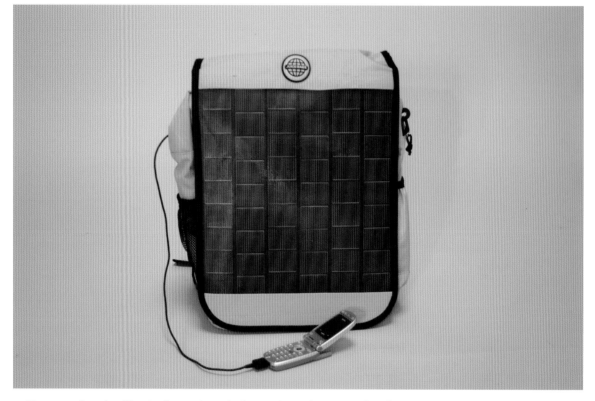

For people who like to be out and about, but also remain plugged-in, these Reware Juice Bags are a dream come true. The solar panel on the back of these bags made up of 52 solar cells collects enough sunlight to generate electricity to keep cell phones, PDA's and digital cameras charged. The bags are big enough to haul your laptop, and with the right battery accessory you can even keep it running. There's even a reversing diode that ensures that your batteries aren't drained. Juice Bags come with a Universal Car Charger Female Socket and are even safe in the rain. Of course, the bags are more efficient in direct sunlight, but even on cloudy days the juice keeps flowing. These bags won't be able to save you if you get lost (unless you have a GPS device on you), but they'll keep you happily entertained.

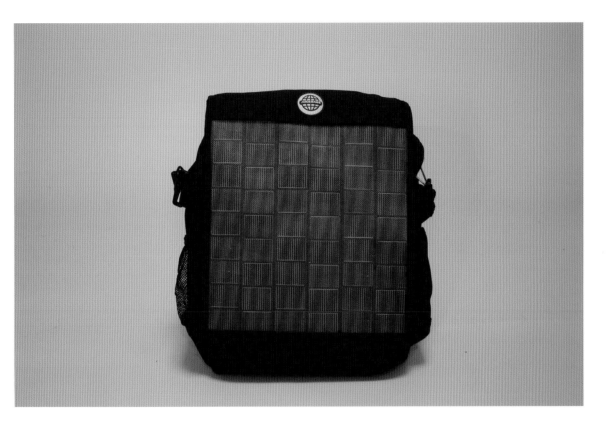

GREEN FABRICS

WHAT'S IN A BAG? by Maggie Kinser Hohle

Six up-and-coming eco-bag makers reveal their thoughts on everything from production to marketing to consumer awareness, and outline the growing field of eco-accessories.

"Tell me about your closet."

We all carry stuff in bags, but a number of designer-activist-marketing folks have discovered that they're also ideal for making bigger statements. Over the past few years, eco-bags of all kinds have been selling well at high-end retailers like Takashimaya on Fifth Avenue and Fred Segal in Santa Monica, and flying off the shelves of urban indie boutiques.

This trend proves that for a wide spectrum of consumers, green equals hip. But before it can make the leap into mainstream fashion, "green" has to completely dispel what Jimi designer Mike O'Neill calls "that hippie crunchy granola thing. Unfortunately," says O'Neill, who had a successful advertising and marketing career before he went into green design, "most of commerce is about perception."

At the beginning of 2005, Andy Krumholz launched Escama, a company that restyles and sells Brazilian bags crocheted out of recycled can tabs. The traditional bags he found in Brazil were "really wild-looking artifacts," he says, but before risking his livelihood on the concept, he interviewed all of his female friends about their handbags and found out that style really counts. "The first bag they would tell me about was always the most outrageous, the prized possession that gets out on their shoulder maybe twice a year." Jonathan Marcoschamer and his brother, also former marketers, founded Ecoist on the same understanding. Their first product is a series of bags woven out of recycled candy wrappers. "If we really want to make an impact," says

Marcoschamer, "if we really want to expose the Ecoist message to the masses, it's got to be about style. Once they're conscious of how the product was made, they'll pay the premium, but no one's going to buy something because it's eco-friendly. They'd rather make a donation."

In a way, buying eco-bags is a donation, whether to the cooperatives or indigenous craftspeople who produce them, to the determined battle to recycle as much vinyl billboard, newsprint or packaging as possible or to the nascent movement to jumpstart the public into accepting, and someday demanding, recycled plastic. What's intriguing about these donations is that there's no sacrifice involved, not like in the early days of green fashion when you had to buy a frumpy hemp skirt to feel good about yourself.

Because the new producers commit to style first, the money spent on these bags fulfills the consumer's desire to dress to impress, or to enjoy superior functionality in a very basic accessory. The people who run and market these companies don't do it with the mentality of fundraisers. No doubt about it, this is not charity, it is a brand of textbook supply and demand capitalism where the money spent on eco-bags ends up as a solid investment in an environmentally sound cycle.

Marketing the New Green

It's no coincidence that most of these eco-bag producers were formerly in marketing. Unlike accessories that come from designers proper, these products

spring from a professional reading of the consumer's mind. And the consumer's mind today is at least troubled, if not racked, by guilt.

These marketers and bag makers have identified our deep-seated and increasingly insistent need to act on what we all know is happening. They have developed their companies and products as part of a well-considered manufacturing and marketing cycle. By identifying the common desire to look great and carry stuff efficiently, these bag makers have created an environmentally and socially responsible manufacturing process that threads its way through existing marketing and retail channels, increasing consumer consciousness as a by-product.

Jonathan Marcoschamer and his brother developed the Ecoist brand as a philosophy that identifies the market as they see it: addicted to convenience, a little lazy, but ultimately conscientious. "We want to make acting on our conscience part of the main stream," Jonathan says. For him, this business is an opportunity to learn about environmental and social responsibility. That his company sells bags made by fair-wage cooperatives in Mexico and pays royalties to the designer illustrates the brand's philosophy, but not its only possible profile. An Ecoist could do much more.

LUCKY magazine has been ridiculed by the thinking press as a purely commercial, even morally bankrupt publication, but Lenore Espanola says her product fits well into its mix, and Marcoschamer says Ecoist, which has been in LUCKY, Teen, Elle, Good Morning America and, naturally, the eco-friendly

PLENTY, actively pursues the celebrity road to success. "If consumers learn from what they see in the malls and on TV, you've got to be in the malls. Once they see Paris Hilton wearing the bag, they'll buy it and then they'll know we plant a tree for every bag we sell. Branding and marketing is brainwashing, but if you brainwash people with good information, with something that's ethical, then there's nothing wrong with it."

It's not yet clear how huge the new market for eco-goods can become. Interdisciplinary shifts, like marketers moving to manufacturing, ordinary designers moving into green design and green designers of the old school moving into mass market green design will define its size. Takumi Shimamura, for example, began in a decidedly non-environmental capacity, designing trucks and train cars and seating for Subaru, but his *Monacca* experience has led him down the green path. Already he's working on a series of products with Nikka Whisky to recycle the company's barrels, and he's planning *Monacca* lamps and a *Monacca* calculator. Nicky Freegard, Vy&Elle's designer, had a hemp bedding company for ten years, some of which was spent, she says, "banging my head against a brick wall" over the difficulty of expanding a limited market. This time she's determined to get to a mass market, specifically to recycle as much billboard as possible. Three-quarters of the way through 2005, Vy&Elle had sold 10,000 bags and in three years has reclaimed 27 tons of billboard, all of which is recycled.

Can handbag makers change the world? Says O'Neill, "Between you and me, no matter how many Jimis we produce, we aren't going to fix the hole in the ozone layer. But hopefully we become some kind of example. We start making other

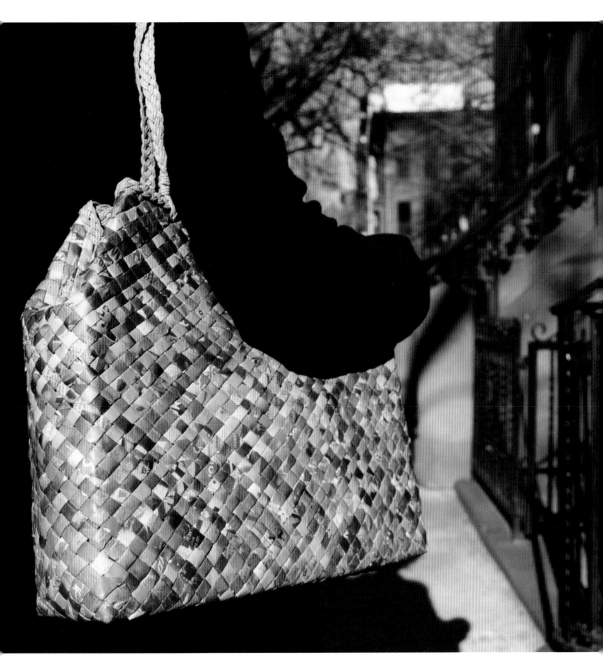

Founded by Lenore C. Española, the bags and purses in the Lenore Collection are made of hand-woven newspapers, magazines and straw. Laminated so the pages don't smudge and smear, the bags are durable and green-chic. Not only do these bags implement creative re-use, but they are also made by women in the Philippines who receive fair wages and would otherwise be in need of work.

people think of how they could start a green company, seeing the marketing angle in that." And Freegard takes her role very seriously, declaring that her products are simply "a tool to make the billboard industry more aware of the opportunities." She's not meeting any resistance. Surprising? "They know they have a poor image," says Freegard. "They want to become green; they've already gotten into the garden hose and linoleum flooring industries."

In Japan, where traditional wooden products like tea ceremony utensils and raised *geta* sandals still have a market and are by definition eco-friendly, the "eco" seal has actually been detrimental to the movement, says Shimamura. He says the eco seal has created a passive role for environmentally friendly materials, which are often used minimally as internal structure, just to give the manufacturer a marketing "excuse."

"We have to focus on the *Monacca* theme," he says. That theme is the complete package: design, materials and the circumstances of production. Shimamura conceived the bag while watching a woodshop machine produce three-dimensional wooden products and ruminating on the exceptional lightness, strength and delicacy of the Japanese cedar, or *sugi*, of a particular Kochi Prefecture workshop that uses only trees felled in thinning. He developed a special machine and needle for the final sewing of the canvas lining onto the *sugi* shell, and insists on only eco-friendly materials, like real lacquer for the coating and edible cornstarch for the adhesive. "It's true that it makes it much harder to produce," he admits.

This resolve resonates with a market that is not limited by nationality or age, though it may be more Internet-savvy than any other. Jimi went live on coolhunting.com and Gizmodo just three weeks before Christmas in 2004, and two days later had close to 400 orders from as far away as Sweden. To O'Neill, who had been developing the product "in the wilds of Massachusetts" for an entire year, the high-speed surge into existence was overwhelming. "Word of mouth's on steroids for sure," he says. Shimamura sells many of his bags through the *Monacca* site and the site of Japanese retailer arenot, and Hip&Zen is a main Internet retailer for several others.

Word of mouth among eco-bag producers is pumped up too. Perhaps they see their separate causes as pieces of an organic whole, but these people have a refreshing, if unusual, "pay-it-forward" attitude, introducing buyers to one another's products and offering advice without a trace of professional jealousy.

The Down & Dirty Process

When the salesman is the marketer, the designer and the concept man, he's committed to the whole ecological cycle of production. To these people, the process is more than a matter of delivery estimates and production schedules. From sunny Tucson, Arizona, Nicky Freegard may hear from her crew who's washing billboards in a hangar in Wisconsin that the material is frozen. She appreciates them, she feels for them. Washing down 300 billboards at a time is no picnic. "It's heavy, it's dirty, it's a real labor of love," she says. And when Vy&Elle is able to claim only 20-30% waste in production, and then manage

to get all of that recycled into hoses or linoleum by the billboard company, everyone knows what it meant in terms of actual, physical effort. When the cooperatives working with Escama, Cia do Lacre and 100 Dimensáo land a wholesale contract for fabric so they're no longer gouged in the local market, Andy Krumholz in San Francisco celebrates their victory. When he sees the latest uploads of the women's bios on the site, tears well up in his eyes as he realizes that his little business has helped pay the bills for not 12, as in the beginning, but 42 artisans in Brasilia.

None of these companies is more than a few years old, but all have future plans that go much deeper than adding just another product to just another line. O'Neill says that following Jimi will be an iPod nano holder, maybe the only one designed from the start to be produced of recycled polycarbonate. Ecoist will investigate other similar production situations where communities with a strong weaving tradition surround a manufacturer with recyclable packaging. Vy&Elle will be moving into an unexplored market for recycled vinyl: office supplies like binders and notebooks, and plans to sell in Office Max and Home Depot. What's important to Freegard and all the rest is the big, big picture. "We're making a little difference in a big world. If I were just making handbags, I'd be pretty depressed."

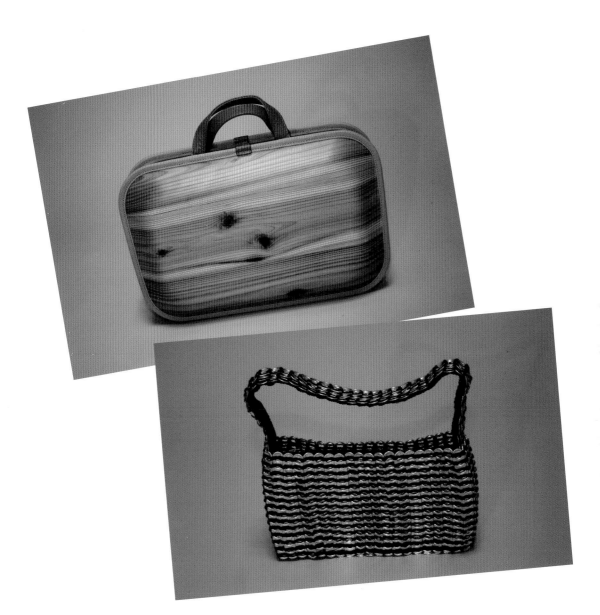

Top: *Monacca* bag made from *sugi*, Japanese cedar; bottom; Escama bag made from can tabs.

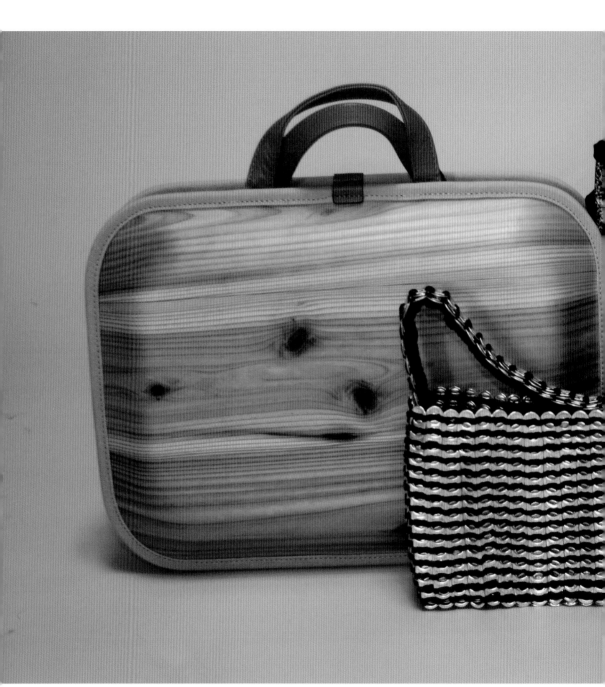

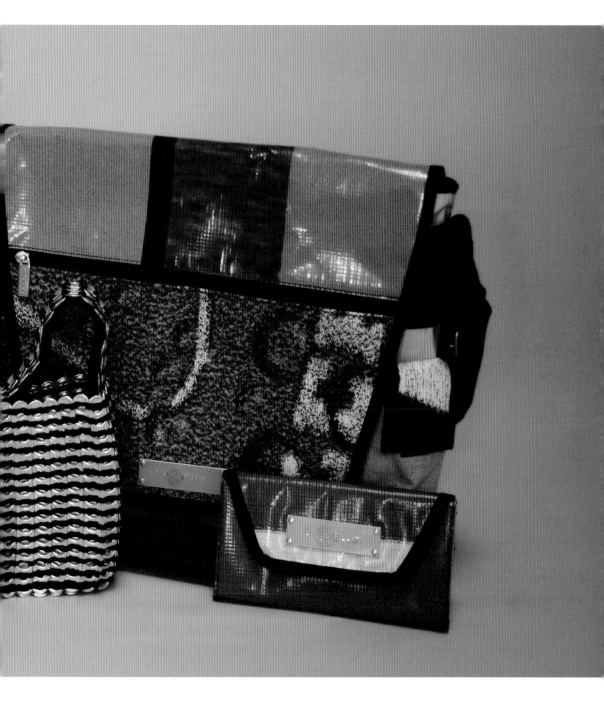

Who would think that typically unwanted materials could look so good? The range of style found in these bags speaks to the innovative approaches by the designers, making the best out of the materials at hand, whether they are soda can tabs, discarded wood or old billboards.

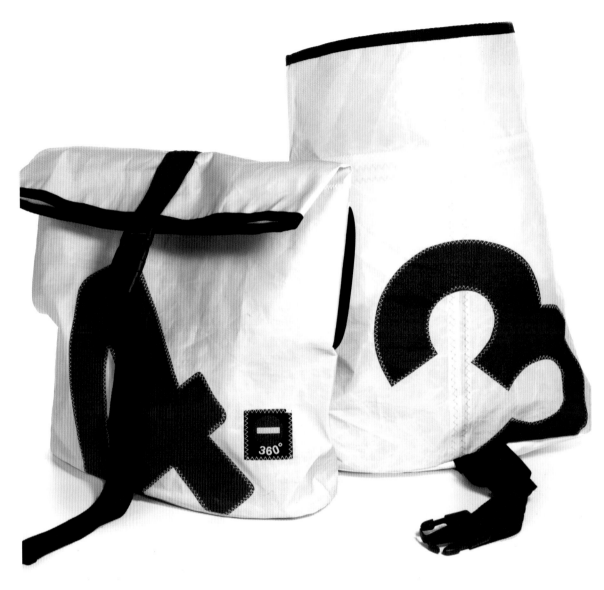

Is there anything savvy designers can't make into a stylish bag? Judging by these, the answer is no. Above, bags made from recycled boat sails; an interior tag details the sail's previous life, providing information about the craft it was used on, the type of sail it was and the waters it sailed upon. To the right, these images showcase four more kinds of recycled materials used to make bags (see the essay about bags on page 112). From top to bottom: recycled newspapers, *sugi* (Japanese cedar), recycled billboard, recycled can tabs.

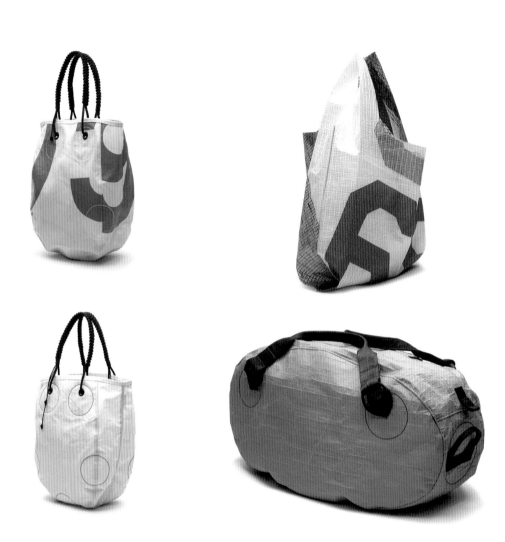

Stuart Sproule and Barnaby Killam started Red Flag Design in 2004, interested in crafting bags from materials with histories that could be continued in new forms. From the high seas to your shoulders and hands, these bags, totes and wallets are made from discarded Kevlar, Dacron and recycled laminate sails, durable and stylistically unique.

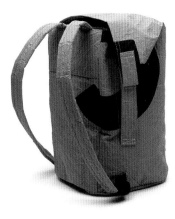
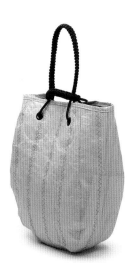
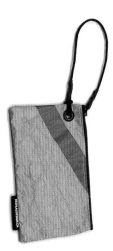
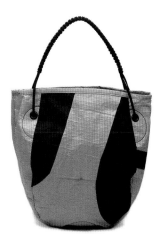
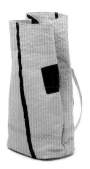
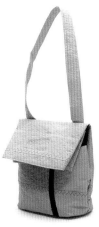

American Apparel:
Natural Never Looked So Bloody Hot *by Buzz Poole*

Spend enough time talking with a few of the folks at American Apparel and you will be amazed how quickly the conversation strays from the topic of T-shirts to rooftop gardens of succulent plants or the prospect of installing a middle school for the children of employees at the company's Los Angeles headquarters, though the solid-colored, logo-free garments are at the core of every tangent. As all of the literature about the company mentions, American Apparel is not a successful business plan, it is a successful lifestyle, one grounded in respect for its employees, its customers and the environment they all inhabit.

"We're not politically correct and we're not boring," Alex Spunt, the company's Content Manager, boasts as she takes the phone outside to catch a smoke and talk about the company's look, a mastery of bad lighting and photo red-eye turned to sex appeal. In mentioning my admiration for the crafted low-fi look she quickly retorts, "It's not pretend. We're shooting people we know. It's not a snapshot aesthetic. It is what it is."

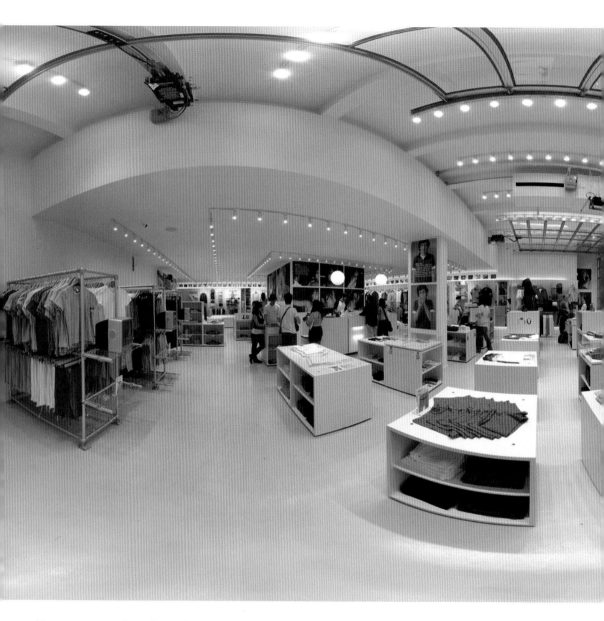

The same as American Apparel's ads possess a straightforward, sexy simplicity, so too do their stores. This store, located in the ultra-trendy Brooklyn neighborhood Williamsburg, like all aspects of the company's public face targets young, hip shoppers that subscribe to minimalist, DIY, socially aware aesthetics. In the case of the stores, this means everything from the white floors, walls and ceilings to the barebones shelves and display racks. All of it exists for the sole purpose of showcasing the garments. The world over, when you step into an American Apparel store, you know what you'll find: a brilliantly marketed, wildly popular, green aesthetic.

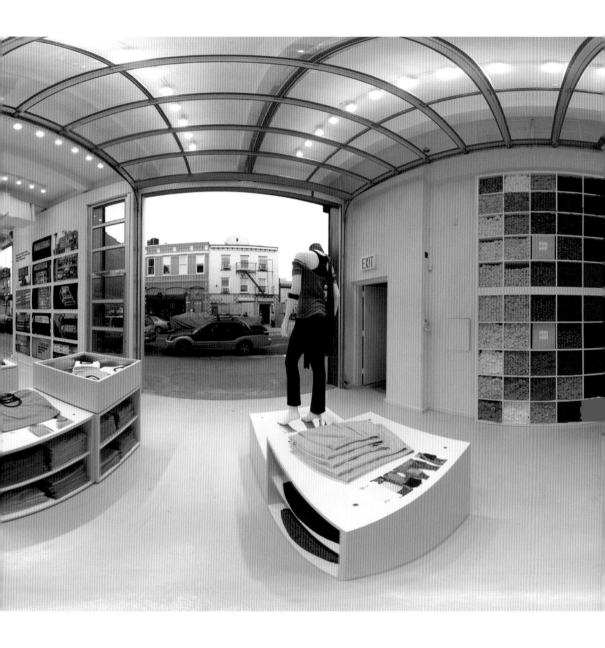

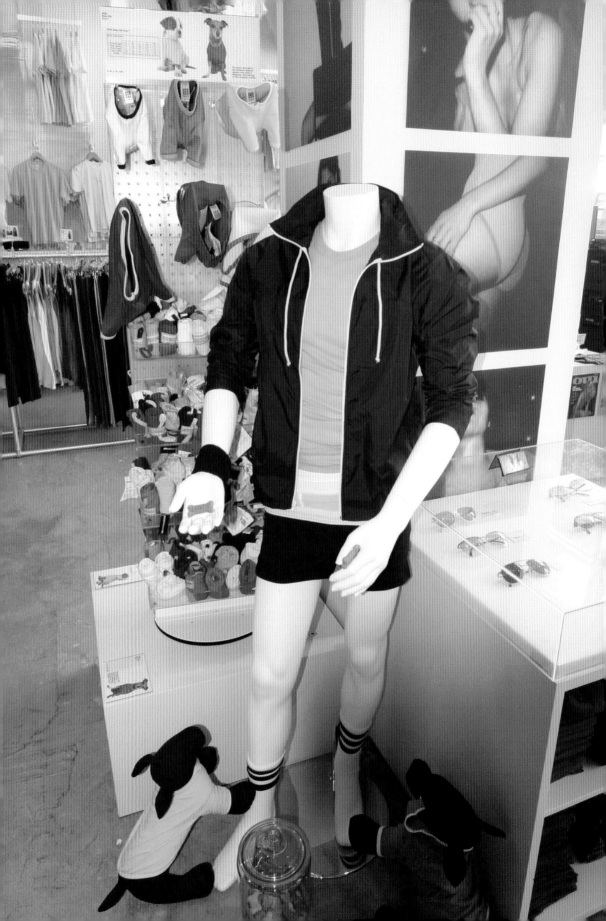

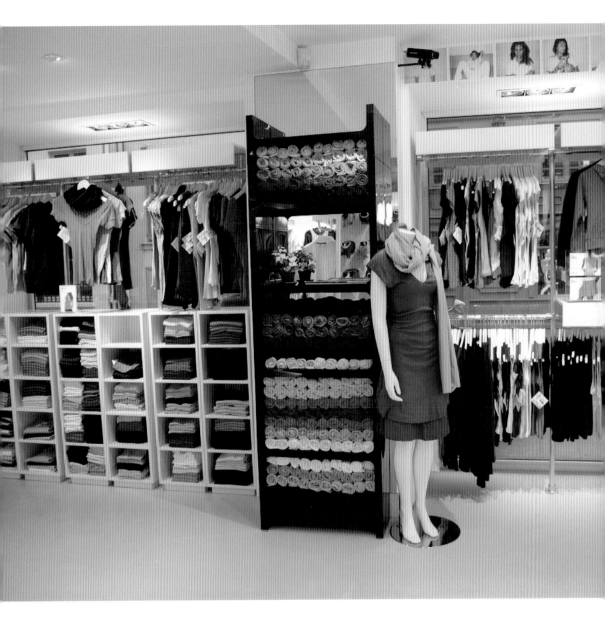

Even in Paris, France, the stores looks the same. Clearly, color schemes have been considered in these displays, which are starkly eye-catching against the white and black.

So when Roian Atwood, Coordinator of Community Relations and Environmental and Organic Programs, gets talking about recently installed solar panels atop the factory's 40,000 sq. ft. roof, his excitement is not just due to the fact that they will generate as much as 20% of the plant's electrical needs, it's a direct result of his knowledge that this addition improves the company as a whole by decreasing the impact of the ecological footprint the facility creates. Hence the ease that conversation flows into the kind of light bulbs in the factory or gallons of water saved with every flush of a toilet or the pros and cons of planting a garden of native plants on the roof in order to reduce the ambient heat and increase the efficiency of the solar panels.

Atwood understands that business is about longevity and for him and his cohorts at American Apparel the "crossover between human systems, environmental systems and business systems" is the means to achieve a long-lasting presence in the world of garment production. Take a look at the sales numbers and it is obvious that the American Apparel approach works: Sales in 2001: $20 million; sales in 2002: $40 million; sales in 2003: $84 million; sales in 2004: $140 million and projected sales for 2005: $210 million!

These numbers are astounding really, especially when you consider that nothing American Apparel does is traditional. The company's public face Dov Charney (on a hiatus from speaking to the media at the time of writing this piece) is notorious for picking up women on the streets, asking them to model and then giving them a job. These people don't even have formal meetings; new ideas spring from water cooler chit-chat and then get passed around.

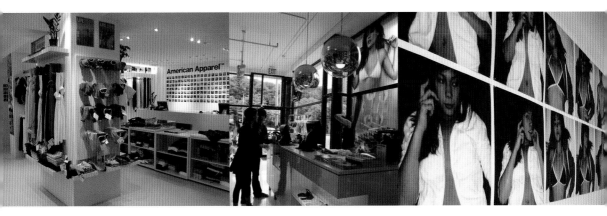

One such new idea that promises to increase American Apparel's reputation for being the vanguard for marketing clothes that promote a lifestyle is the introduction of the Sustainable Edition. Unlike the conventional line, the Sustainable Edition, as Atwood sees it, is made from organic cotton in the hopes of "making organic as savvy, sexy and respectable as any other fashion garment." The problem, however, is that organic cotton production has a long way to go in the United States, and Atwood should know since he is on a first name basis with the few organic cotton farmers still in business.

Why does organic cotton cost more? After it gets picked, the cotton travels to a spinning mill where it becomes yarn. From the spinning mill, fiber brokers act as the liaisons between the mills and buyers of yarn. Every month, American Apparel processes eighty 40,000-pound containers, one of which is organic. Due to aphids, organic yarn is stickier by nature and slows down the processing of the cotton and adds cost in the time and energy required to clean the machines.

Because of this added cost, it is no coincidence that the marketing behind the Sustainable Edition differs from that of American Apparel's conventional products. The company recently reached an agreement with Whole Foods. The chain will be the exclusive retail source for the organic products. The arrangement makes sense. People who shop at Whole Foods already pay a premium for organic produce and the myriad of natural products offered; these shoppers don't need much convincing when it comes to paying a bit more for a shirt that is not only made by workers earning fair wages, but is organic to boot.

The other advantage the Whole Foods deal allows is that the Sustainable Edition won't compete with the garments in the American Apparel retail stores (which at the time of writing number worldwide at 85, with more than 45 in the works).

In selling these similar, yet different products, American Apparel's deft marketing strategy sells the young, urban, sexy look, and the look is the heart of the business. The ability to sell the style accounts for the company's success. Yes, the company prides itself on how the shirts have a more form-fitting cut; the collars and cuffs are designed to stretch less than other brands; the thong underwear is made from leftover T-shirt fabric scraps, and all of this is true. If American Apparel didn't appeal to its fans through endless billboard and print advertisements, however, all the great and innovative things about the company would be nothing more than good intentions. Good intentions change the world, but only when the public at large latches onto the idea. Luckily, American Apparel makes no secret about their intentions, plus they can sell people on them, which works out for the employees, the consumers and the planet.

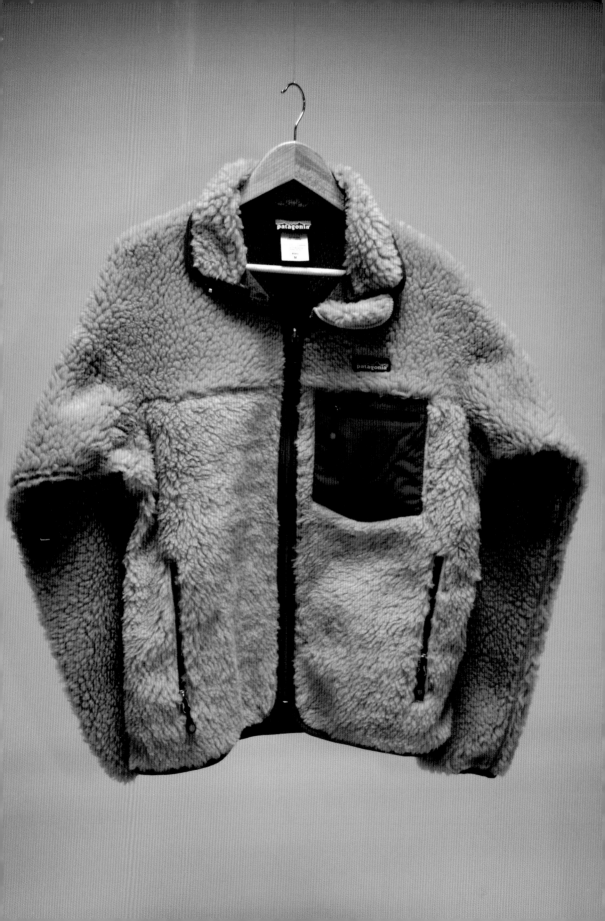

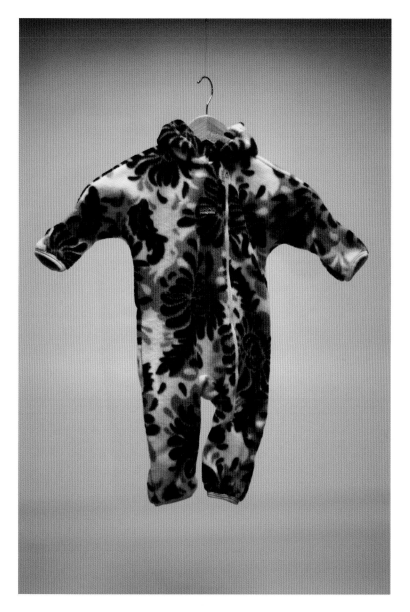

Patagonia clothing isn't just for mad-capped mountain climbers, hard-core kayakers and hell-bent hikers; the company has a whole line of kids' clothes. Made to the same standard of quality as any of the items in the adult line, the children's clothes incorporate green design as well as practical design. Take this Baby Synchilla Bunting for example, colorful and environmentally sound, the gusseted inseam makes diaper changes a breeze.

Patagonia has long been ahead of the pack when it comes to innovative, environmentally responsible clothing design. The company's PCR (post-consumer recycled) Synchilla fleece can be found in over 30 products. Made from plastic soda bottles, over the years Patagonia has kept 86 million bottles out of the trash. The company has also developed PCR filament yarn for use in certain of their products. A blend of post-consumer feedstock (soda bottles, polyester uniforms, tents) and post-industrial feedstock from yarn and polymer factory waste, this yarn is rugged enough to stand up to the company's high-standards for performance.

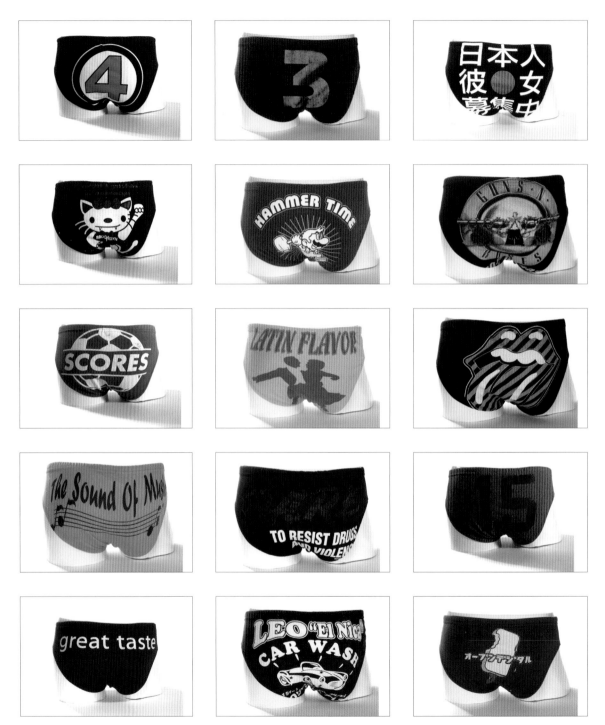

Speedos have never looked so good! We've all cherished a T-shirt at one time or another, maybe the one given to you by a high school sweetie pie or the one you bought at your first concert. Designer Philip Heckman figured out a way to extend the lives of those keepsakes:

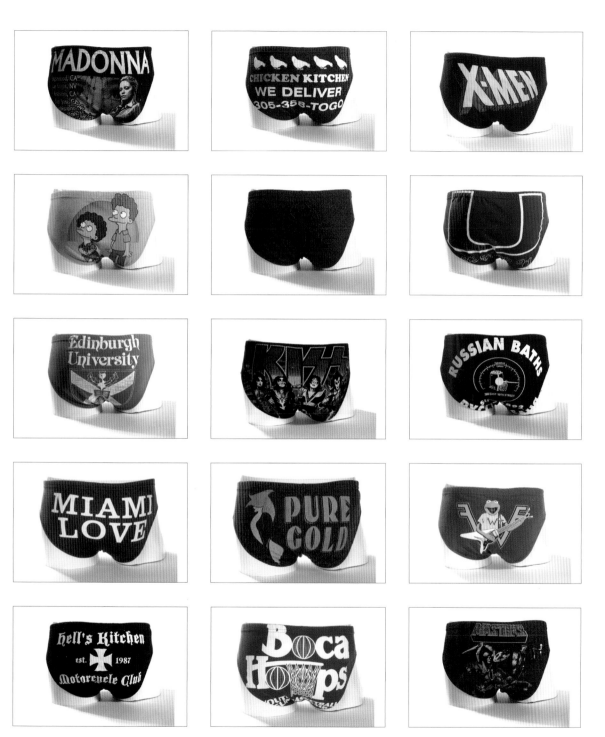

make them into swimsuits. Low Tee's are lined with lycra and equipped with elastic; creative reuse has never been so form fitting.

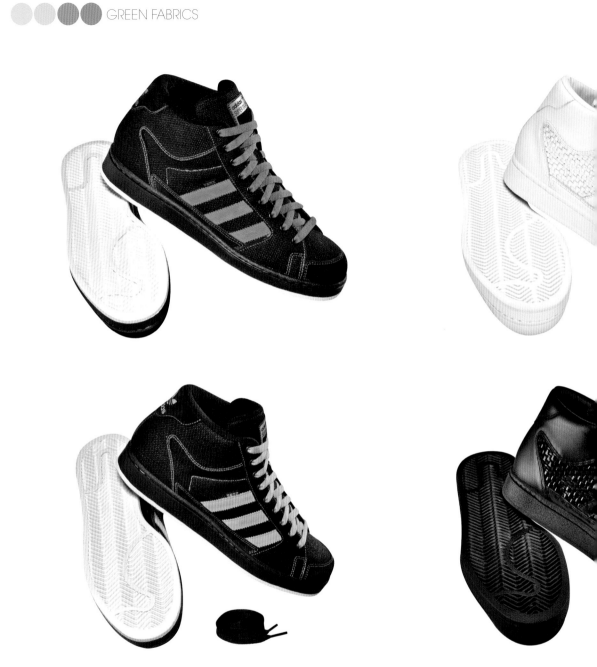

Since the 1970s Adidas has helped define the cutting edge of footwear. The three styles shown here are all environmentally responsible reissues of old school kicks from way back then. The Super Skate Hemp, Super Skate and Super Skate Lo Hemp are designed

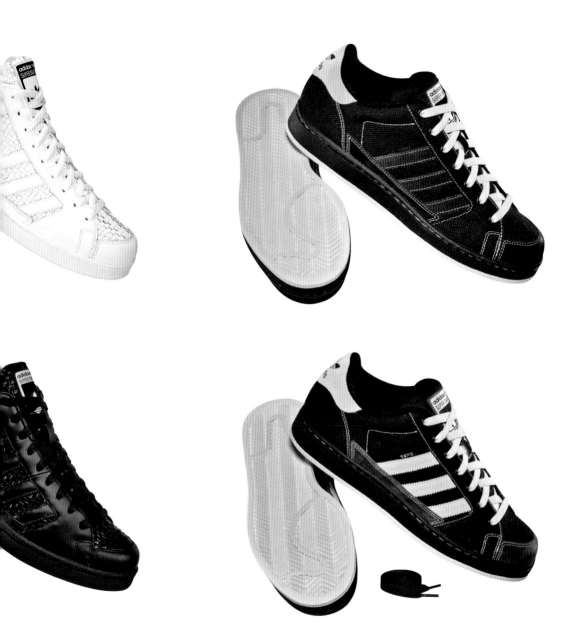

for skateboarders but will appeal to anyone interested in shoes that respect the ground they tread on. Natural rubber soles, woven hemp uppers and woven hemp laces give these retro sneaks 21st-century street cred.

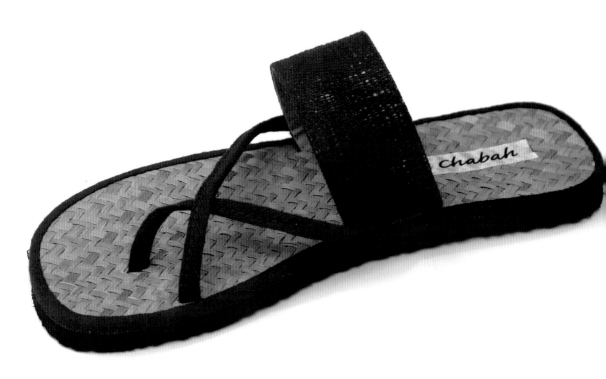

Chabah sandals from northern Thailand are designed and handmade by locals making fair wages. The regional influence is apparent in the traditional patterns and materials, which include woven grass and rope. Pictured above, the Aphrodite; on the opposite page, the Phaedra (top) and Athena.

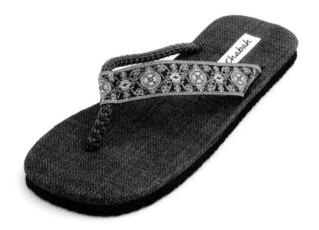

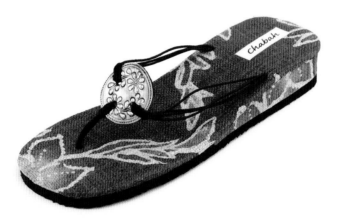

Spotlight On: Alyce Santoro (Creator of Sonic Fabric) by Buzz Poole

If you've ever been on a sailboat, you know the importance of the senses when it comes to making the boat move. Slackened, loose sails flap in wait of the wind and the snap of fabric when the sail fills with a gust is unmistakable. More than just sound, 6 12-inch strips of material attached to the sails, called "telltales," provide visual indicators that help with navigation and keeping the sails in the right positions. Alyce Santoro grew up sailing and as a child she tuned into these aural and visual cues, and let them power her imagination. On the boats she spent time on, old audio cassette tape was used for the telltales. "Tape works well," Santoro explains, "because it's light, durable, dries quickly, and is very sensitive to the wind. When I was a kid, I used to imagine sound

coming off the tape if the wind hit it just right. Beethoven, or the Beatles, or Cat Stevens, or whatever my dad had recorded onto the tape."

Today, Santoro lives in Brooklyn, where she still pursues her passions for sailing and cassette tapes, both as a means to support herself by teaching sailing lessons and to spur her creative output. Though she dabbles in any number of multi-media art projects, her current focus is on sonic fabric, an equal blend of recycled 1/8 inch audio cassette tape with a more traditional material, such as cotton or silk. In 2002, Santoro first converted old tape into fabric when she designed a "Super Hero Shaman Dress." Santoro learned that banded stripes in the fabric identified different tapes from one another, depending on whether it was black tape or chrome, or if the cassettes contained yellow or red leaders. For the "Super Hero Shaman Dress," she used an analog four-track recorder to create the material's soundtrack, "Sounds of (1/2) Life," a mix of everything from old tapes of her high school punk band's jam sessions to Jack Kerouac reading to songs from the White Album, and everything in between. It was a friend who suggested to Santoro that her dress could be listened to, and sure enough, the friend was right. Run a tape head over any piece of sonic fabric and it creates a wonderfully garbled sound that embodies Santoro's concept of "sacred sounds."

A marine biologist by training, Santoro has long understood how the world we inhabit is "all made up of sound on quantum level." By developing sonic fabric, she has figured out how to DJ those vibrations, capturing them in her material. While attending the Rhode Island School of Design to get a certification as

a scientific illustrator, Santoro happily resigned to the fact that she much preferred the practice of art grounded in scientific principles compared to the practice of science grounded in artistic principles. She remembers her approach to research: "I was always seeing how many different ways I could draw a copepod."

Sonic fabric has evolved from a one-off dress to a cottage industry that extends far beyond Santoro's Brooklyn studio; in fact it reaches all of the way to Nepal. Inspired by the same notion that audio cassette telltales could sing in the wind, Santoro, with help from New York City's Tibet House, joined forces with a collective of Nepalese women refugees to craft sonic fabric prayer flags. The merging of the this centuries-old tradition with a very new material is not as unorthodox as it may seem though, since traditional Tibetan prayer flags are inscribed with wind-activated blessings.

The women in Nepal receive recycled tape that they hand-loom with silk or cotton, sometimes using recycled saris for the material. Once they have yards of the fabric, the women hand-sew "Monk Messenger Bags." The design of these bags reflects the monastic ways of the mountainous region where the bags are produced and the bike messenger bags so common in cities like New York and San Francisco. The production of the bags benefits the women and lessens the amount of tape dumped in landfills.

A bit closer to home in Rhode Island, a company produces bolts of sonic fabric that account for the remainder of Santoro's sonic fabric output. While the bags

are only made in Nepal, anything else made from the material comes through this facility. From a warehouse on Long Island, New York, "pancakes" of old cassette tape get shipped to Rhode Island where they are incorporated with materials like cotton and polyester. All of the sonic fabric made in Rhode Island is embedded with Santoro's "Sounds of (1/2) Life." From this material, Santoro cuts patterns for dresses and prayer flags. Color can be tinkered with at the facility depending on what material is used along with the tape. Santoro does all of the silk-screening herself in her basement studio.

Since embarking on this endeavor, Santoro has garnered reviews in places like *Wired* and the *New York Times* and attracted the attention of designers like Lola Ehrlich, who plans on making sonic fabric hats. Through mutual friends, Santoro made a custom-made sonic fabric dress for John Fishman, drummer for the now defunct band Phish. Infamous for performing in a muumuu, this project started with Fishman giving Santoro a box-full of rare tapes from his private collection. She made a collage of sound culled from material like early recordings of Phish, old Sun Ra outtakes and seldom-heard live shows from the likes of Jimi Hendrix and Prince. The custom-made sonic fabric was made, a dress was cut and Fishman wore and played it at a concert in Las Vegas.

Sitting in her studio amid the clutter of bolts of this stuff leaned into corners, swatches and pancakes of it covering just about every surface, the inevitable question arises: What do you really want to do with sonic fabric? While Santoro gratefully acknowledges that the products and custom work are both rewarding and fun, she is not looking to launch a textile empire. "Sonic fabric," she says,

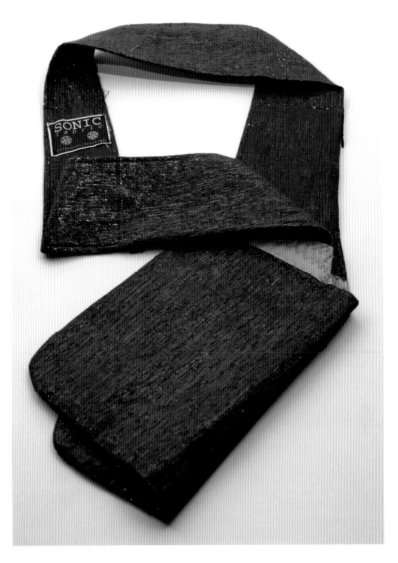

Part Buddhist monk, part bike messenger, Monk/Messenger Bags are handmade from sonic fabric by Nepalese women refugees.

"is not about consumerism. It's a body of work." So, what is the end goal? "The ultimate prayer flag," she answers through a smile. "A sonic sail!"

From the little girl enamored by the telltales on her father's sailboat to the woman interested in the more grandiose notions of how sound weaves the universe together, all Alyce Santoro really wants to accomplish with sonic fabric is to make a usable sonic sail. In a way, the bags, prayer flags, dresses and bolts of sonic fabric are little more than patches in the grander scheme of Santoro's intention to craft this sail; she is already working with a sail maker to develop the design. While it seems unlikely that the completion of the sail equates to the end of sonic fabric, it is clear that the scope of Santoro's creative interests goes well beyond the fabric. It matters not, however, because by inventing sonic fabric, Santoro has charted the way for other savvy designers who follow their dreams, and in doing so figure out one more way to lessen the burden of crazed consumerism on the planet we all share. ⬭

Opposite Page:
The colors in sonic fabric depend on what kind of tape was used (black or chrome), what color leaders the tape contained and the kind of fabric that is blended with the tape. All patterns on the sonic fabric, like the orange, are silk-screened by Santoro.

GREEN PAPER

PAPER AS PROGRESS by Colin Berry

Where recycled and alternative papers meet high design.

I'm holding in my hands a catalog created for the 2003 California Design Biennial at the Pasadena Museum of California Art. It's roughly 8 x 11 inches in size, 80-some pages long and printed on 100-pound text-weight paper that makes a deep, satisfying snap as I flip the pages. Its covers are printed with four match colors, its interior pages with two match and four process colors. Photos and illustrations of everything from sports equipment to cosmetic packages and trendy furniture explode from the bright white pages. The text— 8-point Verdana, in black, halftones and color throughout—stands out as clear and crisp as an autumnal country morning. Created by the San Francisco-based firm Chen Design Associates (CDA), the document is printed entirely on recycled paper. Everything about it is first-rate. More than an ordinary exhibition catalog, the fact that it's printed on recycled paper proves something many graphic designers don't know about, may be deceived by, or simply deny.

"Eighty percent or our projects are on recycled," says Josh Chen, creative director at his namesake CDA and art director on the PMCA project. "Recycled paper has gotten a bad rap, but lately paper companies have made great strides. The quality is amazing. In many cases, you can't tell the difference between virgin and recycled."

With Chen's catalog as proof, the moment to understand that difference between virgin papers and various recycled and alternative papers is now, when world and U.S. consumption of paper is at an all-time high. According to the Worldwatch Institute, the average American uses some 660 pounds of paper per year, a typical worker about 12,000 sheets annually. An average mid-sized university goes through more than a million sheets of bond and letterhead every month. Although Americans compose five percent of the world's population, they consume (and produce) more than one-third of its paper. Only about 50% of this is recycled (much of it is shipped to China for packaging), but more than 90 percent of the U.S.'s printing and writing paper is still made from virgin fiber. By 2010, demand for all paper will increase by 32 percent.

Let these statistics be the designer's wake-up call. Professional creatives have a particular responsibility, and must teach themselves more respectful ways of using natural resources. "Design is at the very center of a challenge recognized by both business and society," explains Richard Grefé, executive director of the American Institute of Graphic Arts. "The profession's success will depend on how designers internalize this challenge during their creative process." For designers, making use of recycled paper is one of the easiest ways to start.

The good news: recycled paper is better than ever. Dozens of mills and manu-facturers are creating new lines of superior options for the working designer. New Leaf, Mohawk, Neenah, Domtar, Fox River and more than a dozen other companies sell a range of coated, uncoated, copy and specialty papers in a variety of weights—all with sizeable percentages of recycled fiber. High-quality recycled paper is plentiful, and dropping in price. Clients are starting to ask for it, often because they believe using it says their business is a responsible one. And designers who spec and implement recycled are increasingly happy with the results.

Brian Dougherty, an award-winning green designer and partner at Celery Design Collaborative in Oakland, California, says designers face twin barriers when considering recycled paper. The first is psychological: overcoming outdated perceptions that recycled is inferior. Doubters should peruse the detailed and ongoing listening survey commissioned by Conservatree and available online, where respondents report that in nearly every instance, recycled paper performs as well as its virgin counterpart, from its use in copy machines to qualities of strength characteristics—tear, tensile, elongation, stiffness—to clarity of printing. Designers' second barrier, according to Dougherty, is the steep learning curve required to inform themselves about (and confidently spec) alternative papers. With this in mind, Celery publishes an annually updated "Ecological Guide to Paper" that collects the best companies and products into one linked website.

Opposite:
The 2003 California Design Biennial, created by Chen Design Associates. Over 80 pages printed on recycled 100-pound text-weight paper; the covers are printed with four match colors; the pages are printed with two match colors and four process colors. Whether clothing or product, the photographs of all the items featured in the catalog jump off the page, a testament to the potential of recycled paper.

It's important to make clear that the two products will never be identical. Jeff Mendelsohn is president of New Leaf, which makes and sells more than 20 different recycled papers: "A super-bright white or ultra-premium coated paper is a finely tuned product," he says, "and you can't fine-tune recycled. But basic coated papers? Opaques? Text and cover? Letterhead? Recycled does extremely well."

The key to satisfaction in working with recycled paper seems to be getting to know it. Josh Chen reports that CDA chooses paper they've used before and are confident about how it performs. Experimentation is key: "We learned lessons early on about how to maximize, how to print designs [on recycled] with the kind of quality we were hoping for," he says. "You need to work with printers you trust, who know what they're doing, can offer tips, do test runs, adjust curves or color so the desired effect is closer to what you have in mind."

"Like any firm, we have our standard papers we specify most often; they just happen to be recycled," adds Brian Dougherty. "As you get familiar with them, understanding the papers' differences becomes part of your studio's knowledge."

Ann Worthington, an environmental print specialist at Hemlock Printers in Burnaby, British Columbia, suggests that designers are beginning to grasp the nuances of how printing on recycled paper is different than printing on virgin. Not better, not worse, just different. "Comparing virgin to recycled on an uncoated sheet, the surfaces would be roughly the same in terms of ink hold-

out," she says. "Uncoated paper isn't a smooth surface, so the ink gets into the grooves. You'll definitely see a difference between something printed on a double clay-coated sheet versus 100 percent post-consumer."

Yet such nuances are only part of the story. Almost universally, the characteristic most designers like best about recycled paper is the way it feels. "We prefer to print something beautiful on a rough surface," says Bruce Licher of Licher Art & Design in Sedona, Arizona. "Our sensibility is more delicate these days, but in the past, we've designed a lot of our work to look almost third-world-like."

"Tactility is a large part of why we specify recycled," adds Nathan Durant, a senior designer at Elixir Design in San Francisco. "Right now we're printing a one-color letterpress on grade-school construction paper with a lot of recycled content. We like its toothiness. It has a grassroots feel that's very appropriate for certain clients." Josh Chen admits that recycled paper's sensual qualities have always attracted him. "I'm a very tactile person," he says. "I'm always drawn to paper that's a little unusual."

But doesn't recycled cost more? Yes, some are slightly more expensive than virgin paper, but they're beginning to approach one another and, for many studios, the chance to make an ecological difference outweighs the negligible price disparity. But isn't bleach used in making some recycled paper? How does a designer keep from harming the environment in other ways? That's easy: buy products that don't use it; they're widely available. What about alternative-fiber

papers? Many are excellent; shop around and experiment. And how do you know if a company has adopted responsible forestry practices? Easy again; look for the Forestry Stewardship Council (FSC) logo, which has the backing of the Natural Resources Defense Council, World Wildlife Fund, and Nature Conservancy.

In the end, the choice between virgin and recycled is partly a matter of aesthetics: If you're looking to spec a crystal-white sheet of exceptional quality for a conservative client, you probably won't find a recycled option that satisfies. But the choice is philosophical, too: Designers who open their eyes to all possibilities will likely find they can satisfy most clients and do the earth a good turn as well. Mostly, opting for recycled is a way to acknowledge that design can be about more than minute analysis, as in: yes, the bright white virgin sheet is impressive, but is it really necessary? "Designers scrutinize things so closely," suggests Josh Chen. "It should be about the overall feeling of a piece."

A final point: If you and your studio are serious about reducing paper consumption, consider other ways to integrate the "recycled" concept. At Celery, Brian Dougherty re-designs tab folders, door hangers and other paper products in order to maximize his press sheets. And at Werner Design Werks in Minneapolis, principal Sharon Werner sleuths out caches of old unused paper: bingo sheets, butter wrappers, antique envelopes, wallpaper from thrift stores and junk shops. When printing on these, she finds the effect is interesting and innovative. "We definitely have our challenges," Werner says of her current fascination. "It's a labor of love. Still, there's something really nice about the ephemeral quality of a found piece."

Screen-printed on recycled papers, these greeting cards from ferdinand demonstrate how recycled papers can indeed make ink pop off the surface.

Whether in small or large quantity, committing to recycled paper indicates a particular creative philosophy, one more and more in accord with a responsible global attitude. It incorporates all aspects of design, from initial brainstorm to finished product, and the results are worth it. Printed on Fox River Coronado, a brilliant white sheet of excellent quality, CDA's Pasadena Museum catalog is but one of countless great finished products. It complements the spirit of the organization, the aesthetic of the exhibition and the philosophy of its designer.

"By incorporating environmentally friendly products into the earliest stages of design, we're saying we're responsible as designers, that we believe in using resources in the most appropriate ways," Josh Chen says. "We want to be aware of how much we consume, of how to replenish that source. It's not just 'Oh, the paper feels good, and it's pretty,' but instead one choice in a series of well-planned choices." He pauses to consider this. "We think about every decision," he says. "We want to be known for that."

Common Ground and Conscious Choice magazines inform readers how they can make their lives green. The magazines' production values meet its content; the pages are printed on 100% post-consumer recycled stock while the cover is a combination of pre- and post-consumer waste.

newconsumer

THE UK'S FAIR TRADE AND ETHICAL LIFESTYLE MAGAZINE Issue 22 Jan/Feb 2006 £3.00 €4.50

ISSN 1478-8527

be revolutionary

50

WAYS TO START A NEW CONSUMER REVOLUTION

● Fair Trade Interiors

● Recycled Fashion

● How to 'unchain' our high streets

● Which energy company is for you?

● High style with ethical fashion

● Is the supermarket past its shelf life?

● Wangari Maathai

● Thom Yorke

new consumer

THE UK'S FAIR TRADE AND ETHICAL LIFESTYLE MAGAZINE Issue 21 Nov/Dec 2005 £3.00

The Green Edition

Do We Have 'Time' for the Environment?

THE NESTLE DEBATE

Jonathon Porritt

NEW FAIRTRADE COTTON

'Green' Weekends Away

ETHICAL FASHION

The Slow Movement

ALTERNATIVE GIFTS

Grains of truth

As the father of revolutionaries Mahatma Gandhi said, greatness derives from small beginnings. Marian Pallister discovers how from grains of rice, bright futures are growing around the Ganges

There are 40,000 different kinds of rice, but one of the tastiest and most nutritious is organic basmati rice from the land surrounding the Ganges and the Yamuna rivers, which wind their mighty way from the Himalayas into the flood plains of India.

Non glutinous, it is long grained, has a nutty taste and is tantalisingly perfumed – its Hindi name translates as 'queen of scents' or 'pearl of scents'. And being organic, it has no chemical content to sully the bodies of those aiming to make big changes to their health through small new year resolutions.

Small changes can make big difference in anybody's life. Witness the transformation in the communities which grow organic basmati rice.

Khaddar or khadi was the commodity which Mahatma Gandhi said would deliver the poor from the bonds of the rich. The word comes from the Hindi khadar, meaning a very basic woven cotton – the

> Small changes can make big differences in anybody's life. Witness the transformation in the communities which grow organic basmati rice on the floodplains of India

kind which Gandhi wore iconically during his struggle against British-imposed taxes during the 1930s.

Today it is a simple food which bears the name – and it too, has the power to deliver the poor from the bonds of the rich.

The Khaddar Farmers' Federation is the cooperative providing organic Fairtrade rice to Europe. In the middle of 2005, it moved into the British market, selling under the Crazy Jack label.

The Fairtrade premium which the federation had received from sales in Switzerland and France enabled farmers to begin improving local schools, roads and other infrastructure.

Now, with the addition of the British Fairtrade premium means they can look to constructing small bridges and roads to remote villages which become inaccessible during the heavy monsoon rains.

They will also set up a loan system to allow members of the federation to buy seed and meet other production costs, as well as pay for family expenses such as education, healthcare, and the weddings and festival celebrations which are so important in rural Indian culture.

The farmers got together in 2001 and formed a partnership with the rice exporter Sunstar Overseas Ltd.

The 'middle man' system in India can be crippling to small producers who have no clout to negotiate. The formation of this partnership empowered them to get better prices and access new markets.

There are now 572 rice growers in the Khaddar Farmers' Federation and they form one or three groups in India certified to supply the Fairtrade market.

Basmati rice growers are among India's poorest farmers. They traditionally sell to the middle men at the local market and rarely cover their production costs. This can lead them into debt with the middle men, who then have a huge hold over their lives. Although bonded labour is illegal in India today, it is this kind of situation which can push a farmer into making a deal with an agent which ties up his income and

Subscribe at www.newconsumer.org

THRASHING IT OUT The guaranteed minimum Fairtrade price for Indian Basmati rice is £166 a tonne. The farmers also get a Fairtrade social premium of £20.50, which the federation's elected representatives can vote to spend on business, social or environmental projects; and an organic premium of £13.67.

Subscribe at www.newconsumer.org

168

It seems that a new trend in magazine publishing relies on the rising awareness in social and ecological responsibility. In both of these publications, content and form meet on the page. Both *New Consumer* and *Green Living* print on papers approved by the Forest Stewardship Council. *Green Living* even documents the number of trees, gallons of water and pounds of green house gas emission saved through their efforts to inform people how to consume conscientiously.

The letterpress and design studio Blue Barnhouse experiments any chance it gets. Whether they print on reclaimed materials like old topographic maps and wood, or use recycled papers, the results are tactile, beautiful and environmentally sound.

For over 20 years, the Japanese company Muji has been renowned for its streamlined and environmentally sound products. These collapsible, portable desktop speakers are cased in cardboard and fold up almost completely flat.

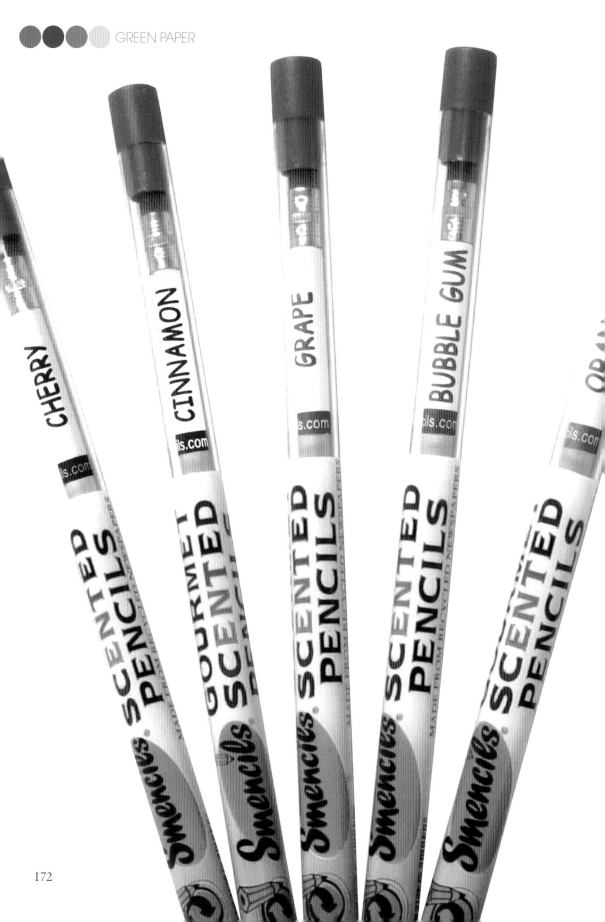

CHERRY

CINNAMON

GRAPE

BUBBLE GUM

OR

Smencils. SCENCILS PENCILS

GOURMET SCENTED

Smencils. SCENTED PENCILS

Smencils. SCENTED PENCILS

Smencils. SCENTED PENCILS

Smencils are scented #2 pencils made from recycled newspapers. The company uses old newspapers to house the graphite instead of wood. Every sharpening reveals more of the layered newsprint. Plus, the pencils smell like all sorts of goodness from cinnamon to chocolate. Smencils come in Freshness Tubes, which are made with recyclable plastic. The erasers are biodegradable; the ferrule (the piece that keeps the eraser on the end of the pencil) is also recyclable. Taking tests has never smelled so good!

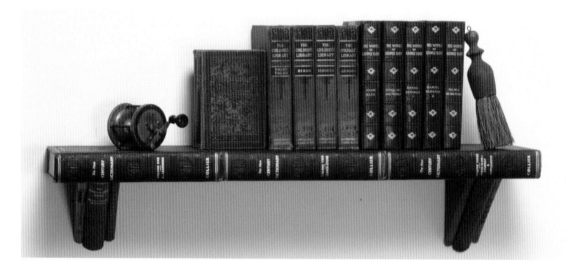

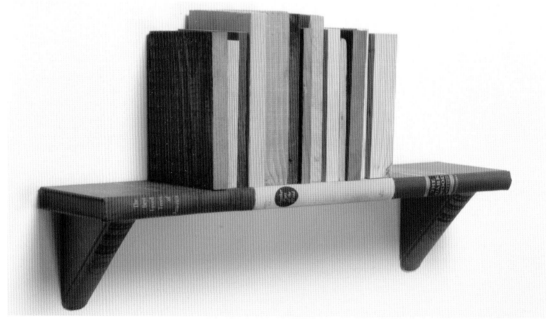

In his essay "Lumber" Nicholson Baker considers the word "lumber" and how it originally referred to more than just wood. This concept inspired designer and book enthusiast Jim Rosenau to build furniture with nontraditional materials. Rosenau's shelves and chairs consist of books that libraries discard or that people dump at recycling centers. After treating them and replacing some pages with salvaged lumber for reinforcement, he builds the books into units like the ones pictured above, often thematic by subject.

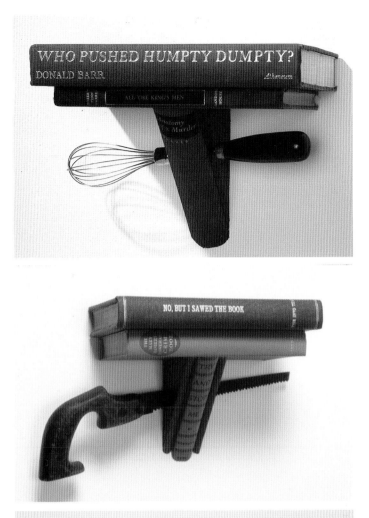

ABOUT GREEN DESIGN

So you've noticed that this page doesn't look or feel like most of the other pages in this book. Why?

We knew that publishing a book called *Green Design* on virgin paper would undermine our credibility, so we printed this book on different kinds of recycled papers. This brown paper is SEK Speckletone Kraft recycled (non-deinked post consumer waste); the other pages in the book are Magno recycled matt; the casewrap is Magno recycled glossy, as is the dust jacket.

Green Design Company & Artist Websites:

GREEN TOYS

Arvind Gupta: www.arvindguptatoys.com
Eric Harshbarger: www.ericharshbarger.org
Gibson Tech Ed.: www.gibsonteched.com
Kenana Knitters Critters: www.dwellingllc.com
LEGO: www.lego.com
Orchard: www.haba.de
Stupid Creatures: www.stupidcreatures.com
Thames & Kosmos: www.thamesandkosmos.com
Tree Blocks: www.trebblocks.com

GREEN OBJECTS

arre: www.store.virginthreads.com/arre.html
Circuit Board Coasters and Lamps: www.uncommongoods.com
Dorothy Spencer: www.uncommongoods.com
Galya Rosenfeld: www.galyarosenfeld.com
Graham Bergh: www.resourcerevival.com
Herman Miller: www.hermanmiller.com
Jeff Davis: www.uncommongoods.com
Jimi: www.thejimi.com
Mark Brown: www.uncommongoods.com
Margaret Dorfman: www.uncommongoods.com
Melissa Kolbusz: www.charcoll.com/kolbusz/index.html
Shaw Industries: www.shawfloors.com
Thai Soda Bottle Rugs: www.gaiam.com

GREEN ENERGY

Dr. Ki Bang Lee: www.kblab.biz
Etón: www.etoncorp.com
Glow Brick: www.gnr8.biz
Group Mango: www.visitmango.com
Nightstar: www.shakelight.notanumberinc.com/flashlight
Reware: www.rewarestore.com

GREEN FABRICS

Adidas: www.adidas.com
American Apparel: www.americanapparel.net
Chabah: www.chabah.com
Ecoist: www.ecoist.com
Escama: www.escama.com
Monacca: www.monacca.com
Patagonia: www.patagonia.com
Philip Heckman: www.lowtee.com
Red Flag Design: www.redflagdesign.ca
Sonic Fabric: www.sonicfabric.com
Vy&Elle: www.ano-ano.com/vy-and-elle.htm

GREEN PAPER

Blue Barnhouse: www.bluebarnhouse.org
Celery Design Collaborative: www.celerydesign.com
Chen Design Associates: www.chendesign.com
Domtar Paper: www.domtar.com
Ferdinand: www.ferdinandhomestore.com
Fox River Paper: www.foxriverpaper.com
Green Living: www.greenlivingmagazine.ca
Hemlock Printer: www.hemlock.com
Hewlett-Packard: www.hp.com
Jim Rosenau: www.thisintothat.com
Mohawk Paper: www.mohawkpaper.com
Muji Cardboard Speakers: www.mujionline.co.uk
Neenah Paper: www.neenahpaper.com
New Consumer: www.newconsumer.org
New Leaf Paper: www.newleafpaper.com
Smencils: www.smencils.com

Green Design Glossary

A selective glossary of terms relavent to the essays and objects herewithin.

Biodegradable: Capable of decomposing under natural conditions.

Bioplastic: A form of plastic derived from plant sources such as soy bean oil and corn starch rather than traditional plastics, which are derived from petroleum.

Biopolymer: A macromolecule in a living organism that is formed by linking together several smaller molecules, such as a protein from amino acids or DNA from nucleotides.

Cradle-to-Cradle Certification: Evaluates a material or product's composition and the human and environmental health impacts throughout its lifecycle and its potential for being recycled, or safely composted.

Design for Disassembly: An approach to design that addresses issues of maintainability and serviceability of products as a means to encourage recycling of materials, component parts assemblies and modules.

Ecological footprint: An indicator of environmental sustainability. It can be used to measure and manage the use of resources, in individual households, communities and businesses based on the sustainability of individual lifestyles, goods, services, organizations, industry sectors, regions and nations.

Ecological Sustainability: The practice of creating ecological developments that meet the needs of today without compromising the ability to meet the needs of tomorrow.

Ecology: The study of relationships between organisms and their environments.

Fair Trade: A partnership based on dialogue, transparency and respect that seeks greater equity in international trade. It contributes to sustainable development and social responsibility by implementing trading conditions that secure the rights of marginalized producers and workers.

Feedstock: Any substance used as a raw material in an industrial process.

Forest Stewardship Council (FSC): A non-profit organization devoted to responsible management of the world's forests. FSC sets high standards that ensure forestry is practiced in an environmentally responsible, socially beneficial and economically viable way. Landowners and companies that sell timber or forest products seek certification as a way to verify to consumers that they practice forestry consistent with FSC standards.

Fuel Cell: An electrochemical engine that converts the chemical energy of a fuel, such as hydrogen, and an oxidant, such as oxygen, into electricity.

Living wage: A wage sufficient for a worker and family to live comfortably.

Lifestyles of Health and Sustainability (LOHAS): A term that refers to growers, service providers, suppliers, marketers and consumers that practice ecological and social responsibility by creating and buying products that benefit the world and its population.

Polymer: A natural or synthetic chemical structure where two or more like molecules are joined to form a more complex molecular structure (e.g., polyethylene in plastic).

Post-consumer feedstock: Synonymous with trash or garbage, post-consumer waste is waste produced by the end consumer of a material stream.

Post-industrial feedstock: Material that has been generated as a by-product of a given industrial or manufacturing process, has been diverted from the waste stream and which has properties significantly different than those of the original material.

Pre-consumer waste or fibers: Material recovered after the papermaking process before use by consumers, such as trim scraps and envelope clippings.

Process Chlorine Free (PCF) Paper: Contains up to 100% recycled content that is unbleached or bleached with non-chlorine compounds.

Reclaimed Materials: Reclaimed materials are any materials that have been used before and are re-used without reprocessing. Reclaimed materials may be adapted and cut to size, cleaned up and refinished but they fundamentally are being reused in their original form.

Recyclable: Possible to use again.

Recycling: To put or pass through a cycle again, as for further treatment.

Renewable Resources: Energy resource that can be replenished on a human time scale; energy resources that are typically considered to be renewable include those derived from solar, wind, geothermal, biomass and low-impact hydro sources.

Restriction of Hazardous Substances in Electrical and Electronic Equipment (ROHS): Effective as of July 1, 2006, this European Union initiative restricts the use of six substances (lead, mercury, cadmium, hexavalent chromium, polybrominated biphenyls, polybrominated dephenyl ethers) in electrical and electronic equipment in order to protect human health and the environment.

Totally Chlorine Free (TCF) Paper: Contains 100% virgin fiber (including tree-free virgin fiber) that is unbleached or bleached with non-chlorine compounds. The term TCF cannot be used for recycled papers because the content of the original paper is unknown.

Vegetable-based ink: Any ink that uses vegetable oils instead of petroleum solvents to carry pigments. Vegetable inks tend to be more vibrant than petroleum-based inks, but dry slower.

Vertical Integration: An arrangement whereby the same company owns all the different aspects of making, selling and delivering a product or service.

Virgin Paper: Non-recycled paper; the production of virgin paper has significant environmental disadvantages when compared to recycled paper production, including a greater impact on forest resources, more air and water pollution, greater water and energy consumption and more solid waste.

Waste Electrical and Electronic Equipment (WEEE) Directive: A European Union directive that aims to prevent WEEE, encourage reuse, recycling and recovery of WEEE and improve the environmental performance of all operators involved in the life cycle of electrical and electronic equipment. The directive requires criteria for the collection, treatment, recycling and recovery of WEEE. It makes producers responsible for financing most of these activities; retailers and distributors also have responsibilities in terms of the take back of WEEE. Consumers of WEEE are able to return WEEE free of charge.

Green Design Index

Green Design
Contributors:

Colin Berry is a contributing editor at *Print* and *Artweek* and a regular contributor to *I.D.* and *CMYK*. He has written for NPR's "All Things Considered," *Wired*, and KQED Public Radio, and is completing a book, *Urban Emigrants*, about his recent move from San Francisco to the Russian River redwoods.

Maggie Kinser Hohle has written about design for 20 years. Her most notable works on environmentally responsible design are the industrial design book, *Y.M.D. Ancient Arts, Contemporary Designs* (1993/Robundo) and her extensive writing about Japanese thatch. She writes for *I.D.*, *Theme*, *Print*, *Dwell*, *Graphis*, *Metropolis*, *Communication Arts* and other magazines. You can also find her at www.maggietext.com.

While working as a toy designer in Chicago, **Dominic Muren** became concerned with the social and environmental impact of his designs. As a result, he founded the industrial design weblog IDFuel.com. He also contributes to Treehugger.com. Currently, he is pursuing a Masters of Industrial Design degree at the University of the Arts in Philadelphia.

Buzz Poole's work has appeared in the *San Francisco Chronicle*, *Blitz*, *East Bay Express*, *Kitchen Sink* and elsewhere.

Writer **Jenn Shreve** (www.jennshreve.com) lives in San Francisco. Her work has appeared in *I.D.*, *ReadyMade*, *Slate*, *Wired* and elsewhere.